# BY NATURE'S DESIGN

Once is an instance.

Twice may be
an accident.

But three or more times makes a pattern.

—*Diane Ackerman*

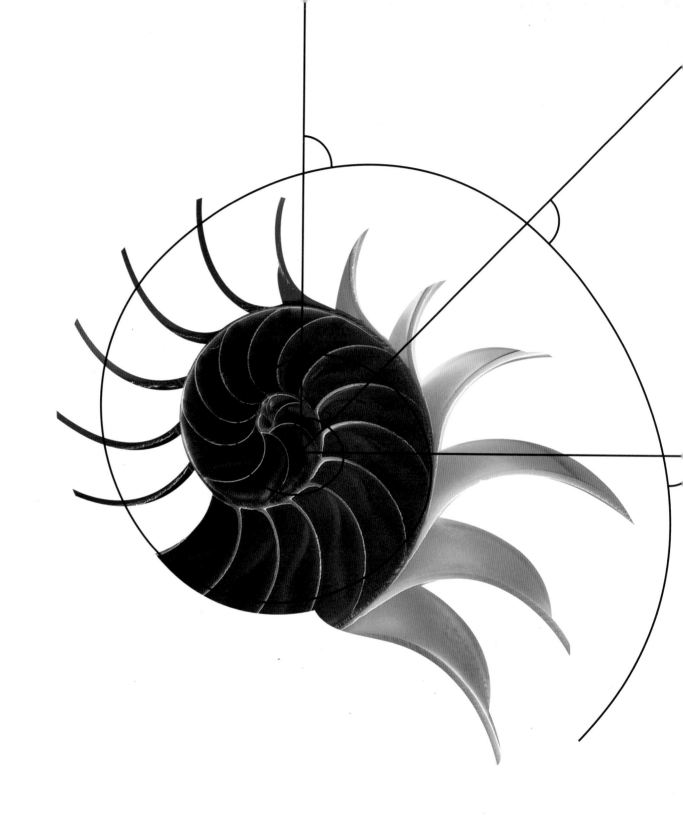

# BY
# NATURE'S
# DESIGN

An
**EXPLORATORIUM**
Book

**Photography by**
    **William Neill**

**Text by**
    **Pat Murphy**

**Foreword by**
    **Diane Ackerman**

**CHRONICLE BOOKS** *San Francisco*

Library of Congress
Cataloging-in-Publication Data

Neill, William.
By Nature's Design:
photographs by William Neill.
p. cm. — An Exploratorium Book
Includes index.
ISBN 0-8118-0444-5
1. Nature photography.
2. Morphology—Pictorial works.
I. Exploratorium (organization) II. Title. III. Series.
TR721.N45 1993
779' .3' 092—dc20                    92-41313
                              CIP

Distributed in Canada by
Raincoast Books,
112 East Third Avenue,
Vancouver, B.C. V5T 1C8

10 9 8 7 6 5 4 3 2 1

Chronicle Books
275 Fifth Street
San Francisco, CA 94103

## DEDICATION

To Peter S. Stevens, author of *Patterns in Nature*

— *the staff of the* EXPLORATORIUM

To my mother and father
who have encouraged my art and
taught me, each in their own way,
to "follow my bliss," and
to my wife Sadhna whose love
brightens all my days.

— WILLIAM NEILL

# Table of Contents

*One*

Spirals and Helixes
16

*Two*

Meanders and Ripples
32

# Foreword  *Diane Ackerman*

**In the diamond quarter of Amsterdam, where hearts are cut every day, I sat on a bench during the violet hour, watching the sun drain out of the sky and a half-moon rise like an Inca god.** A woman in a blue scarf, hurrying home with a net shopping bag full of produce, swerved awkwardly to avoid something in the road. A moment later, she swerved again, and it wasn't until the third swerve a few steps on that I saw the pattern in her gait. Perhaps caused by a hip injury? Just then I realized that a necklace of lights had been forming across the throat of the brick buildings along the canal. At night, Amsterdam opens its veins and pours forth the neon milk of cities. We humans are obsessed with lights. Not random lights, but carefully arranged ones. Perhaps it is our way of hurling the constellations back at the sky. We crave pattern. We find it all around us in sand dunes and pine cones, we imagine it when we look at clouds and starry nights, we create and leave it everywhere like footprints or scat. Our buildings, our symphonies, our fabrics, our societies—all declare patterns. Even our actions. Habits, rules,

rituals, daily routines, taboos, codes of honor, sports, traditions—we have many names for patterns of conduct. They reassure us that life is stable, orderly, and predictable. So do similes or metaphors, because seemingly unrelated things may be caught in their pincers, and then the subtle patterns that unite them shine clear. This is sometimes how the mind comforts itself, and often how the mind crosses from one unknown continent of perception or meaning to another, by using the land-bridge of metaphor. In conversation, we meander like a river. Rocking with grief, a mourning woman keens like a wind-bent willow. The river sings. Unanswered letters dune on a cluttered desk. Families branch. Music curves, spirals, and flows. The spidery mind spins a fragile, sticky web between like things, gluing them together for future use. In part, patterns charm us, but they also coax and solicit us. We're obsessed with solving puzzles; we will stand for hours before a work of abstract art, waiting in vain for it to reveal itself. Why do the world's patterns require our attention? Perhaps because we are symmetrical folk on a planet full of similar beings. Symmetry often reveals that something is alive. For example, the five deer standing at the bottom of the yard right now all blend perfectly into the winter woods. Their mottling of white, brown, and black echoes the subtle colors of the landscape. No doubt the deer were there for some time before I detected them. What gave them away was the regular pattern of legs, ears, and eyes. Then all at once the word *deer* flashed through my mind, and I retraced them with my eyes, this time picking out some flanks and noses, too. *Deer!* my mind confirmed, checking the pattern. Once is an instance. Twice may be an accident. But three times or more makes a pattern. We crave something familiar in a chaotic world. Thought has its precincts, where the cops of law and order patrol, looking for anything out of place. Without a pattern, we feel helpless, and life may seem as scary as an open-backed cellar staircase with no railings to guide us. We rely on patterns, and we also cherish and admire them. Few things are as beautiful to look at as a ripple, a spiral, or a rosette. They are visually succulent. The mind savors them. It is a kind of comfort food. Feast here on some of the wonders in nature's pantry.

# Introduction   *Pat Murphy*

Looking for patterns is part of being human. People search for patterns—and usually find them. We seek familiar forms in clouds, in inkblots, in shadows. A drifting cloud could be a horse's head, or an elephant, or a fish. The irregularities of an inkblot can be seen as bats or butterflies. The shadows of the moon's craters form a face—the man in the moon. This book emerged from the human tendency to look for patterns. It's based on the artistry of photographer William Neill and shaped by the sensibilities of the Exploratorium, an institution de-dicated to helping people learn to notice the underlying unity in the diversity of nature. Loosely speaking, the Exploratorium is a museum of science, art, and human perception. It's a large building that houses over six hundred interactive exhibits—some built by scientists and some by artists. Each year, more than half a million visitors

Similar patterns repeat on very different scales. The cells in the root of a buttercup (below) resemble the wax chambers of a honeycomb (left). An arrangement of hexagons often appears where identical elements are packed tightly together—whether it's on a microscopic or macroscopic scale.

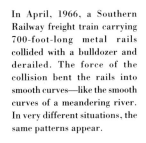

come to this building to experiment and explore. They peer through lenses, listen to echoes, compose music, build a catenary arch, experiment with electricity, and learn about how their senses work. But the building—and the exhibits and programs it contains—are only part of what the Exploratorium is. For me, the Exploratorium is a state of mind. It's a slight shift in worldview, a perceptual sensitivity that makes you aware of things you had never noticed before. Like the similarity between the spiral pattern in the heart of a daisy and the spiral of a seashell, or the resemblance between the branching pattern of a river and the branching pattern of a tree. Frank Oppenheimer, the Exploratorium's founder, saw the search for patterns as fundamental to both art and science. "Art and science are very different," he wrote, "but they both spring from cultivated perceptual sensitivity. They both rest on a base of

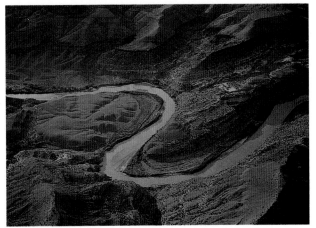

acute pattern recognition. At the simplest level, artists and scientists alike make it possible for people to appreciate patterns which they were either unable to distinguish or which they had learned to ignore in order to cope with the complexity of their daily lives." One such pattern is the motion of the planets—Kepler found the key to their risings and settings when he recognized that they moved in ellipses around the sun. Another such pattern might be the rhythms of language caught in the cadences of a poem, or the patterns of human interaction revealed in a novel. Though the final result is very different—the physicist's equation does not look at all like the poet's sonnet—the starting point is very much the same. In their artistry, William Neill's nature photographs invite the discovery and appreciation of natural patterns. These photographs capture details that a less observant viewer would miss—the sensuous ripples

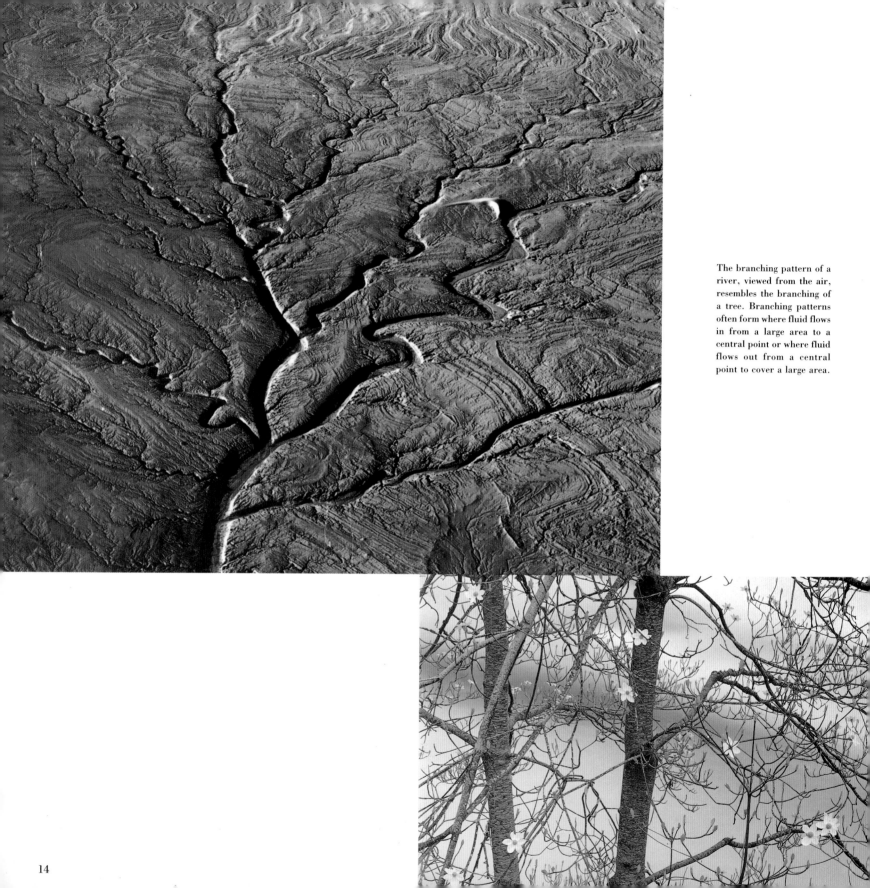

The branching pattern of a river, viewed from the air, resembles the branching of a tree. Branching patterns often form where fluid flows in from a large area to a central point or where fluid flows out from a central point to cover a large area.

This computer-generated image of a fern looks very much like the real thing. Analysis of the fractal geometry of natural forms has led to the creation of fractal forgeries, computer-generated images that resemble the forms of the natural world.

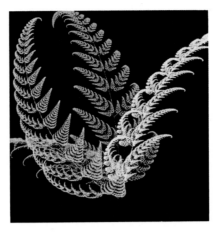

that flowing water leaves in mud, the tracings of veins in an autumn leaf, the intricate cracking of tree bark, the colorful splashes of lichen on a boulder. The photographs reveal that nature, in its elegance and economy, repeats certain forms and patterns. In the text, I have provided some of the explanations that scientists have given for such similar forms appearing in such diverse situations. These explanations are interesting—but perhaps less important than the initial recognition of patterns. The first step to understanding—and one of the most difficult—is to see clearly. As you examine the photographs, keep in mind that nature modifies and adapts these basic patterns as needed, shaping them to the demands of a dynamic environment. But underlying all the modifications and adaptations is a hidden unity. On a microscopic and macro-scopic scale, in situations as different as a train wreck and a mountain stream, nature invariably seeks to accomplish the most with the least—the tightest fit, the shortest path, the least energy expended. Once you begin to see these basic patterns, don't be surprised if your view of the natural world undergoes a subtle shift. In writing the text and studying the photographs for this book, I found myself captured by the patterns revealed in Neill's images. I drove on the freeway, thinking of how its curves resemble the meanders of a river. I studied the cracks in the tar of a roof, the branching of veins in leaves, the radiating patterns of flowers. Everywhere I looked, I found the basic patterns repeating. I hope that this book—like the Exploratorium itself—will help you discover the rewards of finding the hidden patterns in nature.

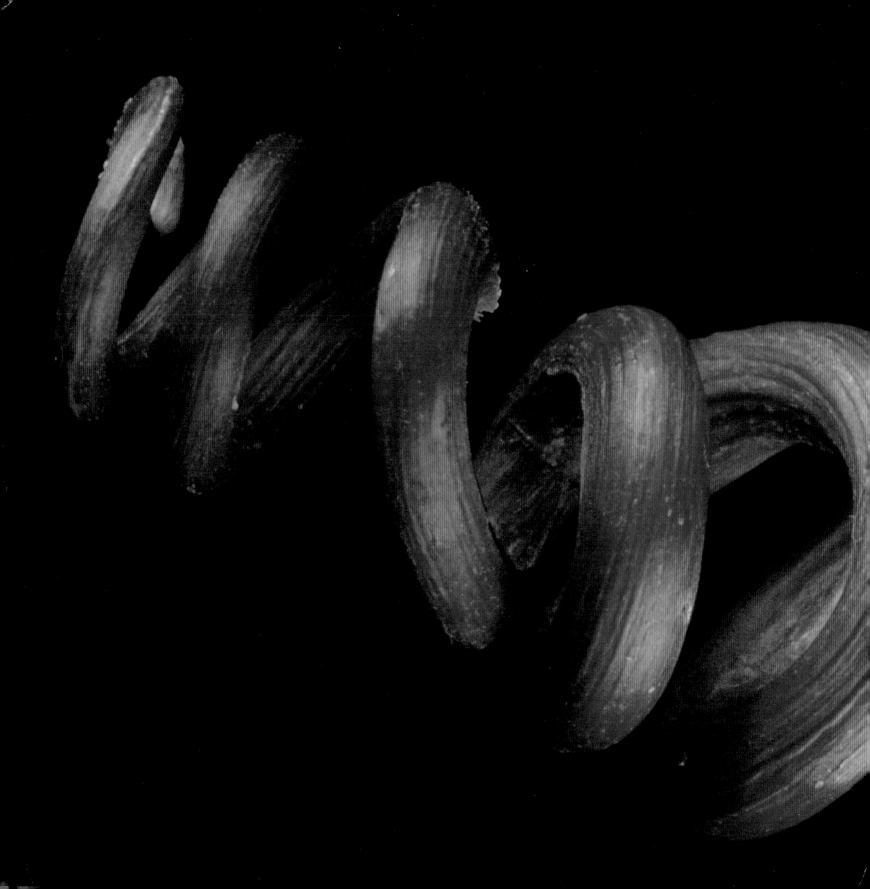

# Spirals and Helixes: The Curves of Life

# Spirals and Helixes: The Curves of Life

Equiangular spiral

Life, more often than not, does not draw straight lines. The world is filled with graceful curves—from the elegant spiral in the heart of the nautilus shell to the twisting double helix of DNA that codes for the nautilus's growth. In the spiral formed by a coil of rope, each successive whorl is the same width as the one before. A mathematician would call this form an *Archimedes spiral*, named for the Greek who first described it. You can find the same spiral in many spiderwebs. After creating a framework of radiating spokes, the spider travels around and around the center of the framework, filling the gaps between the web's spokes with one continuous line. The snail's shell is also a spiral, but close examination reveals that the spiral of the snail shell differs from the coil of rope in a significant way. The spiral of the snail shell grows as it winds around itself, so that each coil is wider than the preceding coil. In 1638, French philosopher and mathematician René Descartes dubbed this form an *equiangular spiral* when he noticed that all lines drawn from the center of the spiral intersected with

Helix

the outer wall at identical angles. The equiangular spiral is the only mathematical curve that retains the same shape while growing only at one end. A snail can't expand the inflexible walls of its shell; it can only add to the open end. But as the snail grows, the shape of its living chamber does not change. If you magnified the spiral of a small snail shell, it would be identical to the spiral of a large snail shell. The living chamber expands but continues to match the contours of the animal that inhabits it. You can also find equiangular spirals in plants and animals that grow by adding identically shaped elements of steadily increasing size. The chambered nautilus builds its shell from many chambers, each slightly larger than the one before. The equiangular spiral accommodates this increase. The animal builds chambers at the end of the coil, growing by adding identical elements. The corkscrew known as a *helix* is another form taken by twisting shapes. In a helix, each loop of the curve is identical to the one below or above —like the coils of a spring or the loops of a phone cord. Like the nautilus shell, the helix is formed by repeating many individual elements. In a helix, elements that are identical in size and shape are arranged to

make a three-dimensional curve. The DNA molecules that carry genetic information consist of many, nearly identical components that form two twisted strands of a double helix. These mathematical forms —the Archimedes spiral, the equiangular spiral, and the helix —along with shapes that combine elements of these three forms, are found throughout the natural world.

Archimedes spiral

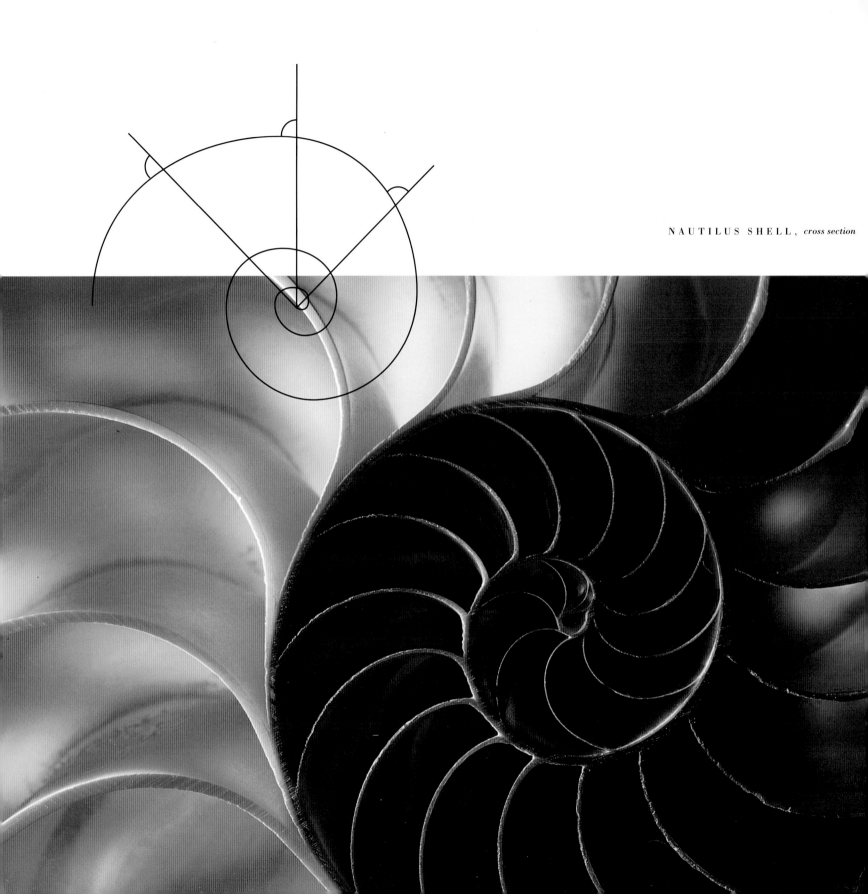

NAUTILUS SHELL, *cross section*

# The spiral shape of the nautilus shell

reflects its process of growth. Initially, the nautilus occupied only the smallest crescent-shaped chamber at the center of the spiral. That was the whole shell. As the animal grew larger, it needed more living space. By adding to its shell, it created a chamber that was the same shape as the original chamber —but 6.3 percent larger. As the animal grew, it created additional chambers—each one 6.3 percent bigger than the one before. Each new chamber is a perfect scale model of the preceding chamber — just a little bit bigger and rotated slightly. An equiangular spiral forms when a growing structure is built up of successive parts that are identical in shape, but increase in size by equal steps. The equiangular spiral is an orderly way to arrange these parts to make a whole.

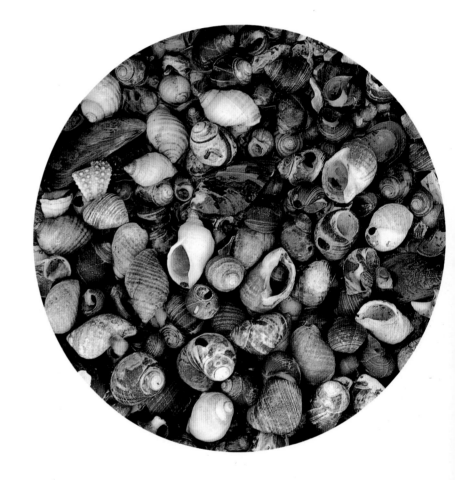

The spiral of a small sea shell and that of a larger shell of the same species are the same shape. If you took the small spiral and magnified it, it would look identical to the big one.

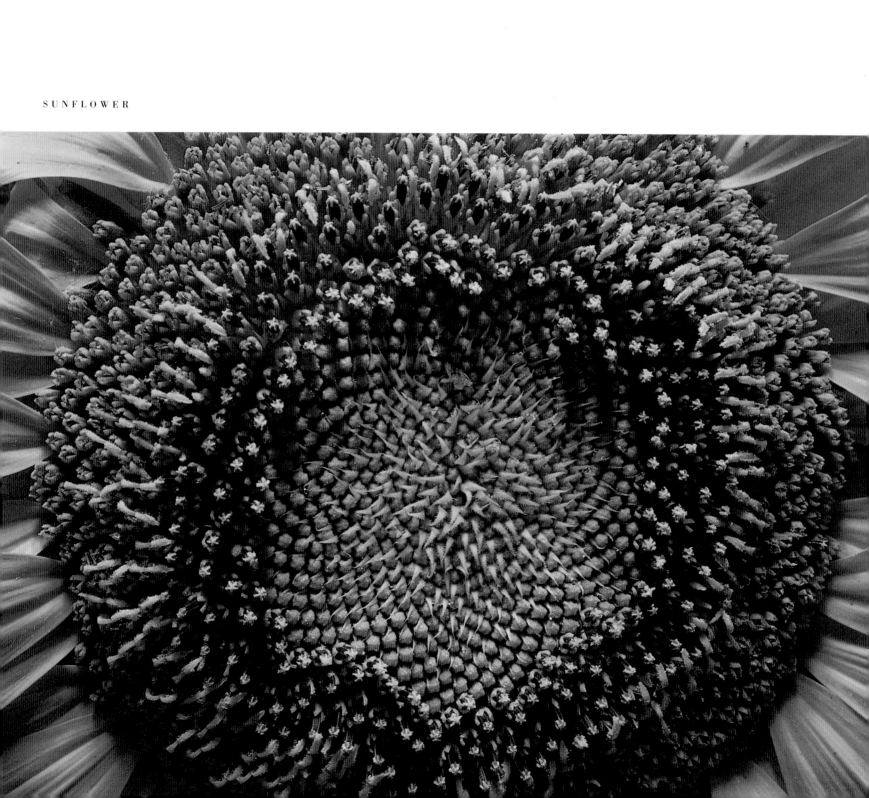

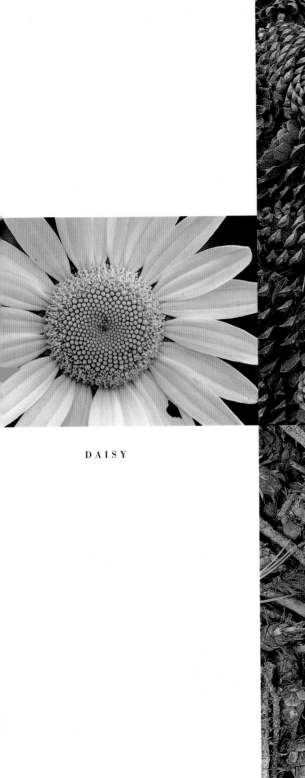

DAISY

The spiral in the heart of the nautilus shell is echoed in the golden center of a daisy. The daisy's center is made up of many tiny flowers, or *florets*. The florets, like the chambers of the nautilus, increase in size with their distance from the center. The oldest and largest florets are at the periphery; the newest and smallest are at the center. The overall spiral shape is created by adding elements that have a shape identical to the existing elements, but a different size. You can see the same principle at work in the florets of a sunflower and the scales of a pinecone.

DOUGLAS FIR CONES

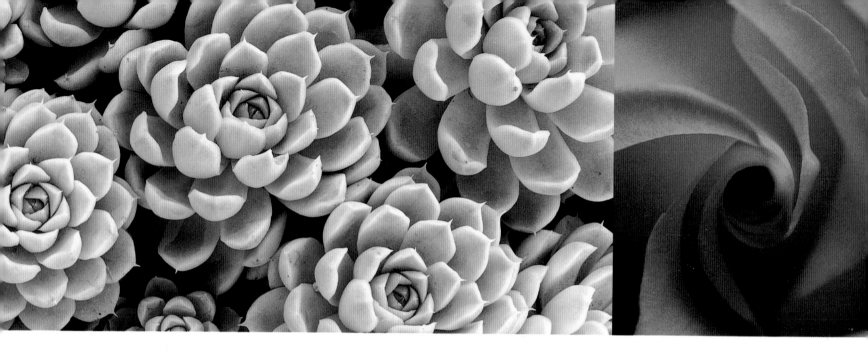

# When a new leaf sprouts

on an agave plant, it doesn't grow directly above the preceding leaf. Instead, it sprouts from a point above the old leaf and partway around the stem. If you drew a line connecting the bases of all the leaves, you would draw a helix up the plant's stem. Since the length of stem between the leaves is very short, the spiraling leaves form a tightly packed cluster known as a *rosette*.

The diagram on the facing page shows an idealized plant, on which leaves are numbered according to their age. The lowest number is the oldest leaf. The spiral indicates the order in which the leaves sprouted. You can see the rosette pattern of tightly clustered spiraling leaves or petals in a variety of plants, including certain succulents, artichokes, cabbages, and, of course, roses.

AGAVE PARRYI

Take a close look at the plants in your garden or in the park. The leaves of many common plants grow in a spiraling pattern. The leaves in these plants may be spaced farther apart on the plant's stalk than they are in the agave plant, but the leaf bases will still form a spiral pattern up the plant stalk.

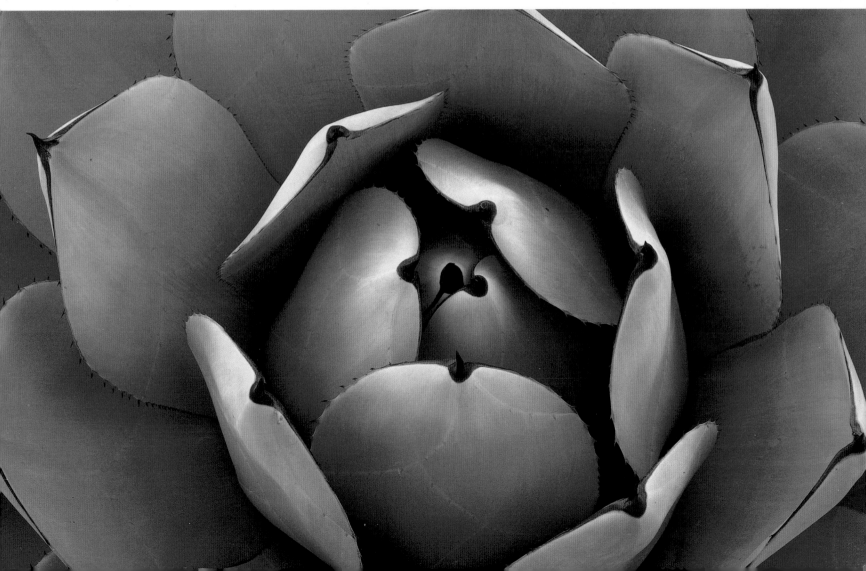

# The tendril of a grapevine curls into a characteristic

corkscrew shape. The tendril coils because the cells on the outer surface of the curve grow more quickly than the cells on the inner surface. If the outside of the tendril bumps into a twig or some other obstacle, the contact causes cells on the opposite side to grow faster. As a result, the tendril changes the direction of its twist to loop around the obstacle.

WILD GRAPEVINE

WISTERIA VINE

BRISTLECONE PINE

## Animal horns often combine

the spiral and the helix in a sort of
extended spiral. Notice that the two
horns spiral in opposite directions. Like
gloves or shoes, the horns in a pair are
generally mirror images of each other.

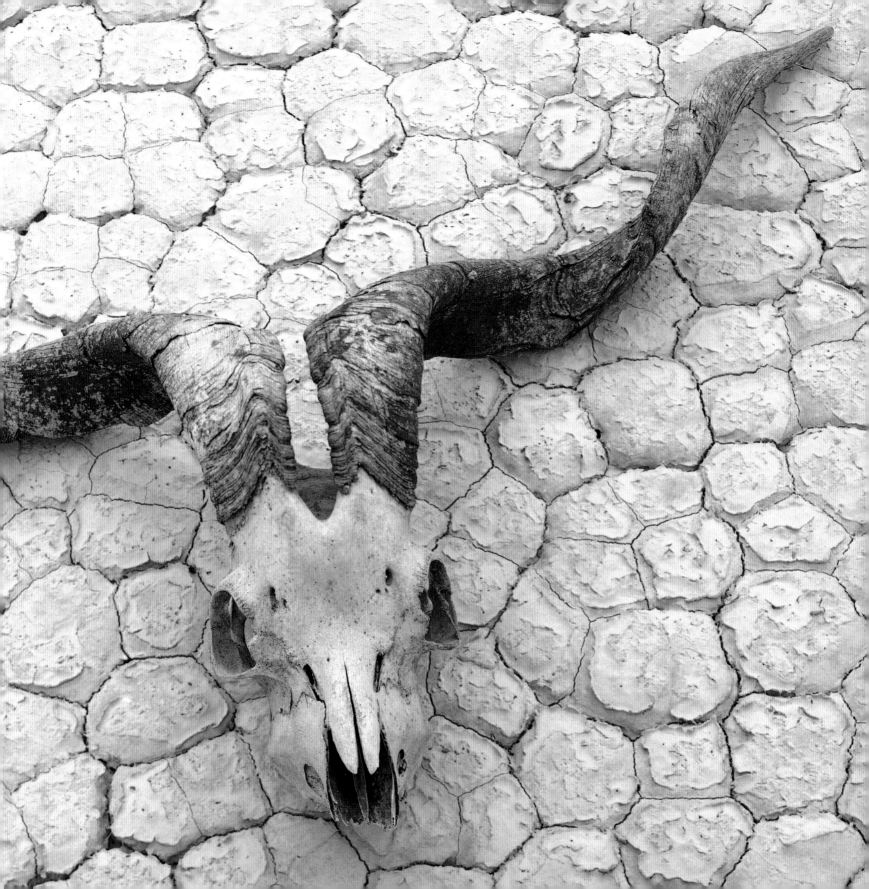

As the bark of the madrone tree dries, it shrinks and pulls away from the tree trunk. The outer surface of the bark dries—and shrinks—more quickly than the inner surface. The shrinking causes the bark to curl into a tight coil.

**The orb weaver spins its web** in one continuous operation, taking from thirty minutes to an hour. First, the spider creates a framework of radiating strands and a temporary spiral scaffolding that extends four or five turns outward from the center of the radiating web. Starting at the periphery of the web, the spider then works its way inward, laying down a sticky thread in a spiral pattern.

SPIDER'S WEB

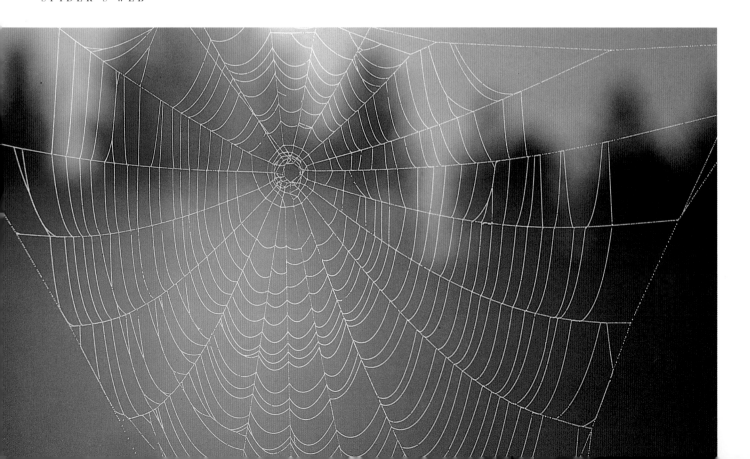

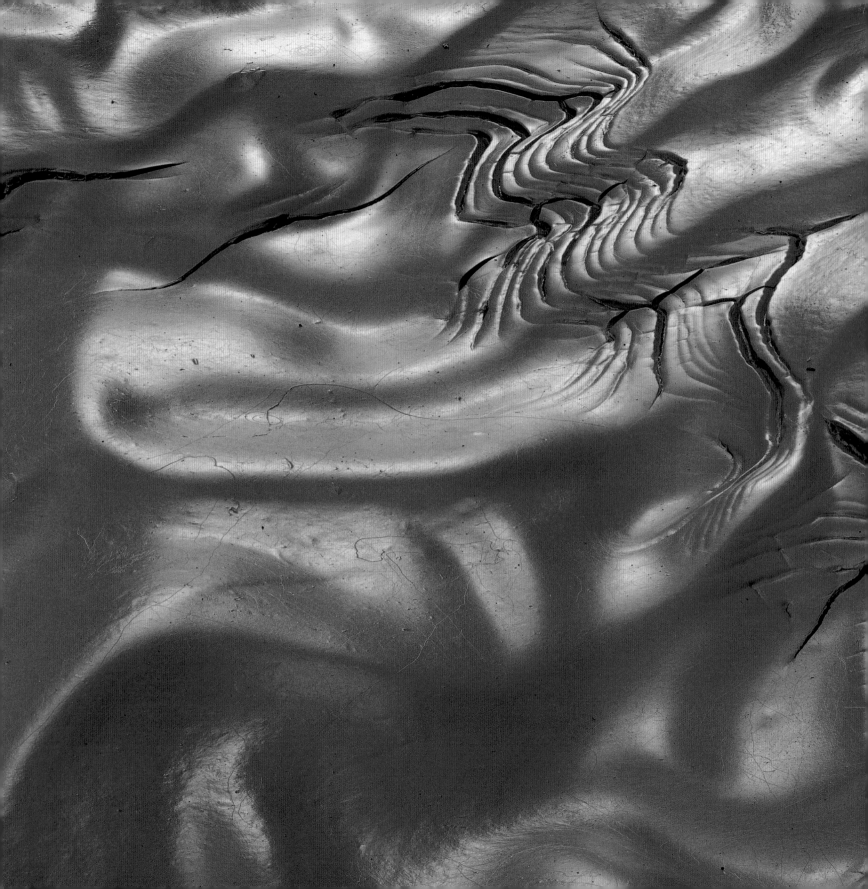

# Meanders and Ripples: Patterns of Flow

# Meanders and Ripples: Patterns of Flow

The transitory movement of wind and water is preserved in natural patterns Flowing water carves the sinuous curves of a river Flowing air—in the form of wind—makes dunes in the sand and ripples in the dunes. Rivers and streams rarely run straight. A stream flowing down a steep hill may follow a direct course for that portion of its journey. But when that same stream reaches a more gradual slope, the flowing water will wander, looping from side to side in curves. These curves are called *meanders*, after the *Maíandros*, a river named by the Greeks for its winding course. Flowing water shapes these curves and modifies them over time. The creation of a meander begins with a slight bend in the river channel—a detour around an obstacle or an adaptation to the terrain. The channel bends, but the momentum of the flowing water carries it in its original direction, driving it against the riverbank on the outside of the curve. This swiftly flowing surface water scours the riverbank, eroding the land and enlarging the curve. Water rebounds from the bank and travels across the channel, carrying away the soil that it has chewed from the bank. If you could trace the course of one

upful of river water, you would see that it follows a looping path—traveling on the surface toward the outer curve of the meander, plunging down across the river bottom to the inner curve, then rising to the surface again. This circulation of the water, hidden from the casual viewer, shapes the river's bends. The rapidly flowing water at the river's surface chews sand and silt from the riverbank. Friction against the river bottom slows the water as it flows across the riverbed. Downstream, on the inside curve of a bend, the water—now moving at a stately pace—drops some of the silt and dirt that it carried. Over time, the action of the flowing water changes the river's course—the channel remains the same size, but gradually moves toward the outside of the curve. The movement of water not only sculpts the river's meanders but also shapes the river channel. If you are looking for a sloping beach on a meandering river, check the inside bank of one of the river's bends. Since this is where the current deposits sand and silt, the riverbed slopes gradually. The outer bank of a meander, where the flowing water erodes the land, tends to drop off sharply. In many ways, flowing air acts much like flowing water. Like water, wind can carry bits of sand and silt for a distance and then deposit this material somewhere new. Like water, wind picks up sand when it is flowing rapidly and drops it when it slows. Wind shapes both sand dunes and the ripples on the surface of the dunes. A dune usually begins when an obstacle slows the wind. A boulder creates a pocket of quiet air on its lee side. The wind that blows over the rock slows down and drops some of the sand it carries, forming a mound. When the mound is large enough, it helps block the wind. Still more sand accumulates, and the dune grows. A ripple on the surface of a dune starts with a smaller obstacle—a pebble, a stick, or even a footprint. Otherwise, the process is the same. One ripple leads to more ripples. After the wind flows over a ripple and dumps its load of sand, it speeds up, picks up more sand, and repeats the process, forming another ripple. Like the curves in the river, sand dunes and ripples migrate over time. The wind picks up sand as it blows up to the crest of the dune or ripple, then drops the sand on the lee side, so that the mound of sand moves in a downwind direction.

**The graceful bends in a river** or stream shape the valley through which the water flows. Over time, under the right circumstances, the flowing water changes course, carving ever-larger looping curves. As the stream wanders over the valley floor, it deposits silt and sand and gravel, forming a flat area known as the river's *floodplain*. Sometimes, a meander curves so drastically that the two inner banks meet, creating a more direct route for the river to follow. The former meander loop may remain, partly filled with water, forming a curved *oxbow lake* on the floodplain.

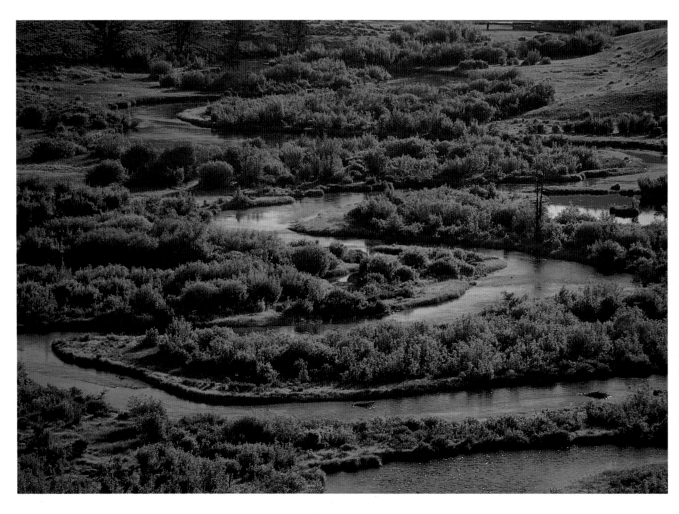

MEANDERING STREAM
*Shoshone National Forest, Wyoming*

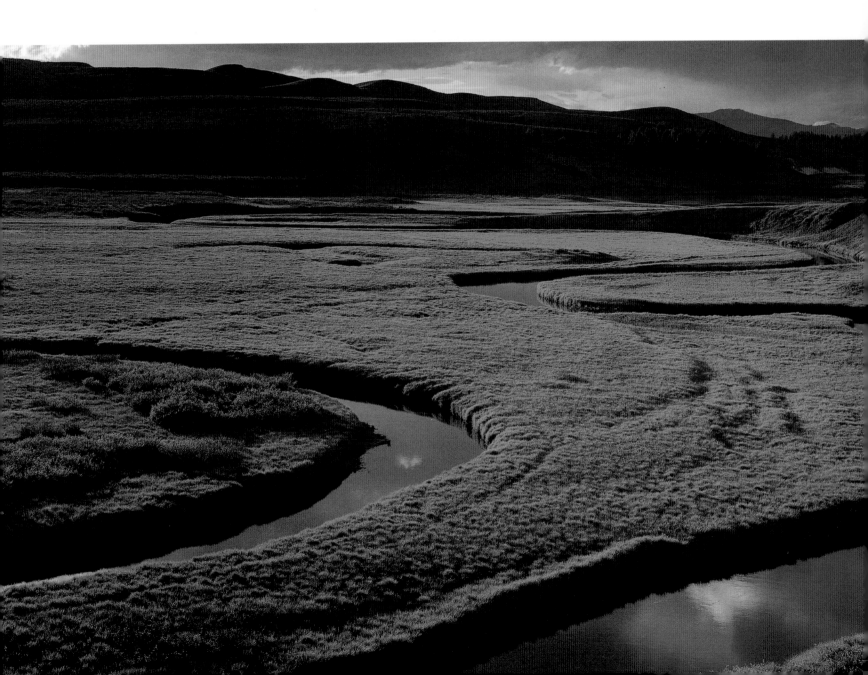

MEANDERING STREAM

*Yellowstone National Park, Wyoming*

The meanders of the Green River preserve its
geologic history. When this river first formed, it
flowed in looping curves across a plain of cobbles,
gravel, sand, and sediments that had eroded from
the Rocky Mountains. The river cut down into
the plain, still following its original meanders,
and eventually carved a canyon in the hard rock
of the mountains.

GREEN RIVER
*Gray Canyon, Utah*

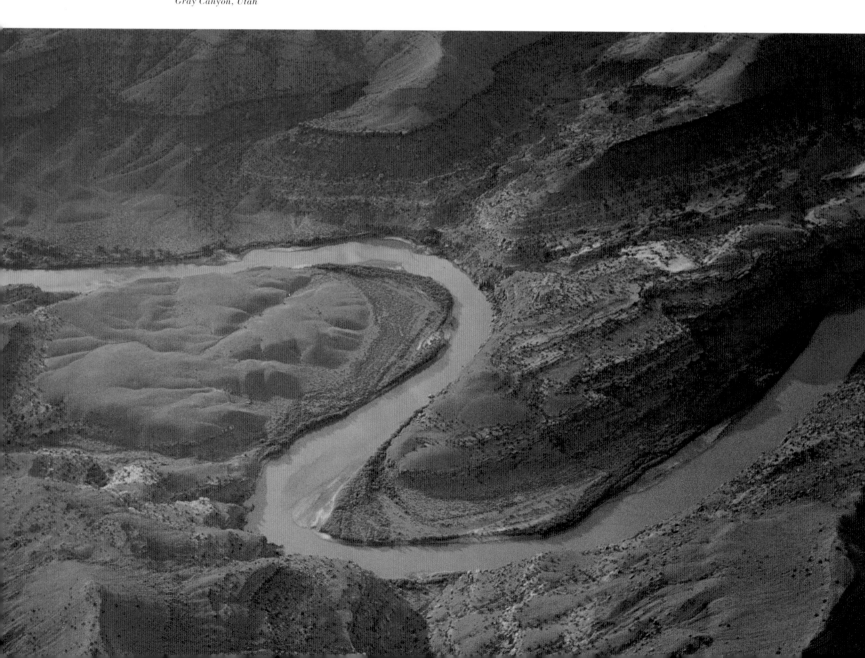

Swiftly flowing water can carry more sediment, sand, and gravel than a
stream flowing at a more leisurely pace. When a river that is laden with
sediment slows down, it may deposit its excess load in the riverbed and
form into a network of branching channels known as a *braided river*.
Each channel in a braided river forms its own set of meanders.

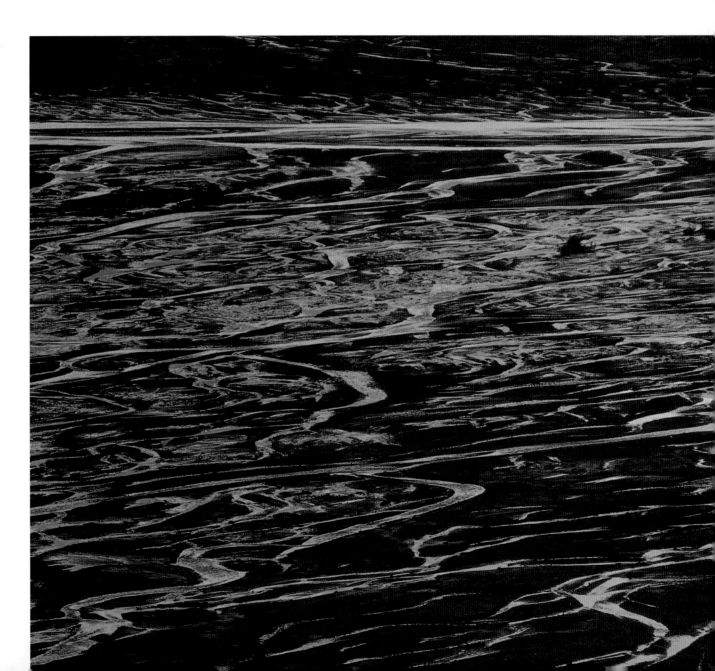

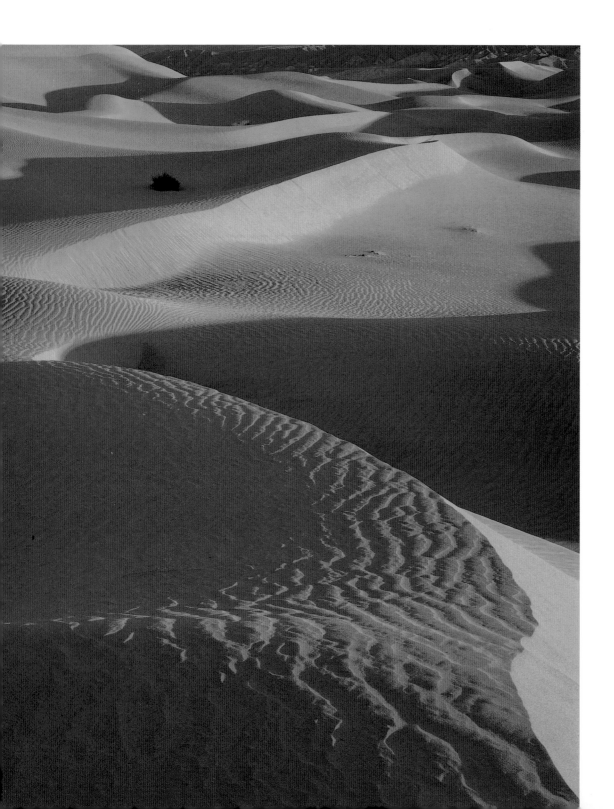

**A close look at a sand dune reveals** the direction of the prevailing wind. The ripples are perpendicular to the direction of the wind. The windward side of each ripple or dune slopes gently; the leeward side drops off sharply, forming as steep an angle as a heap of sand can. Cross-bedded sandstone, the petrified remains of ancient sand dunes, reveals the direction of ancient winds. Fossilized sand ripples and the wind directions that they revealed provided evidence in the 1950s that continents had moved over the eons, one of the first indications of plate tectonics.

*Aerial view*  S A N D  D U N E S
     *Death Valley National Monument, California*

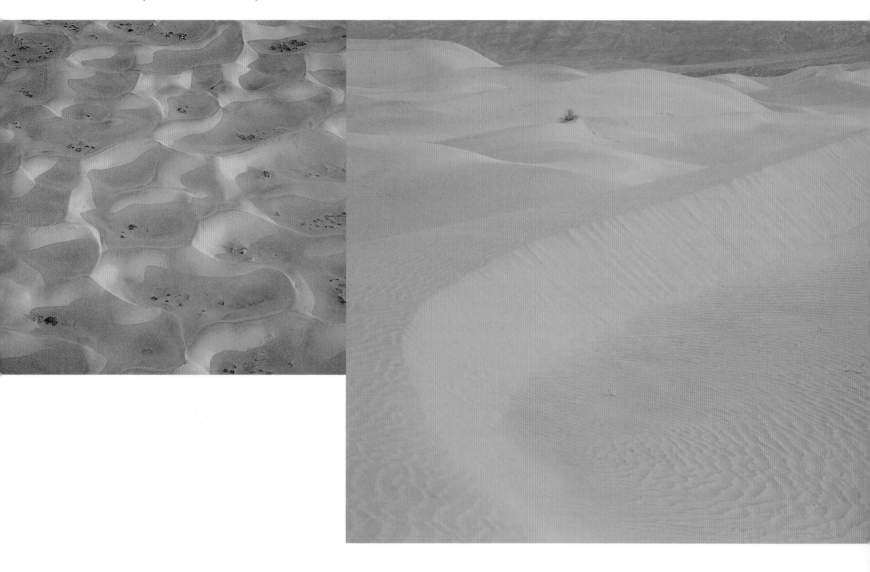

S A N D  D U N E S
     *Death Valley National Monument, California*

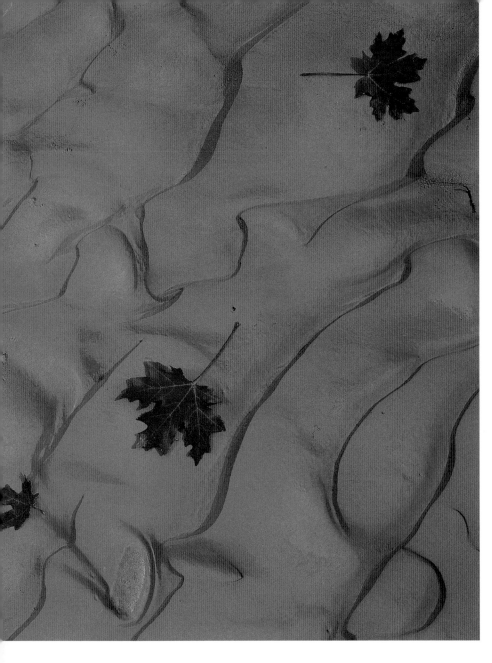

Just as wind creates ripples in sand, flowing water can create ripples in mud. And just as sand ripples indicate wind direction, the shape of ripples in mud reveals the direction in which the water was flowing when the ripples formed: the upstream side of the ripple slopes gently; the downstream edge falls off more abruptly. The size of the ripples is determined by the speed and depth of the flowing water.

RIPPLES IN MUD
*with red maple leaves*

*Meandering pattern on fallen*
COTTONWOOD TREE

## SCALLOP SHELL

The edge of a scallop shell resembles corrugated steel roofing material. In both cases, the ripples make the material stiffer. It's difficult to bend the corrugated metal—or break the scallop shell—along a line that's perpendicular to the ripples.

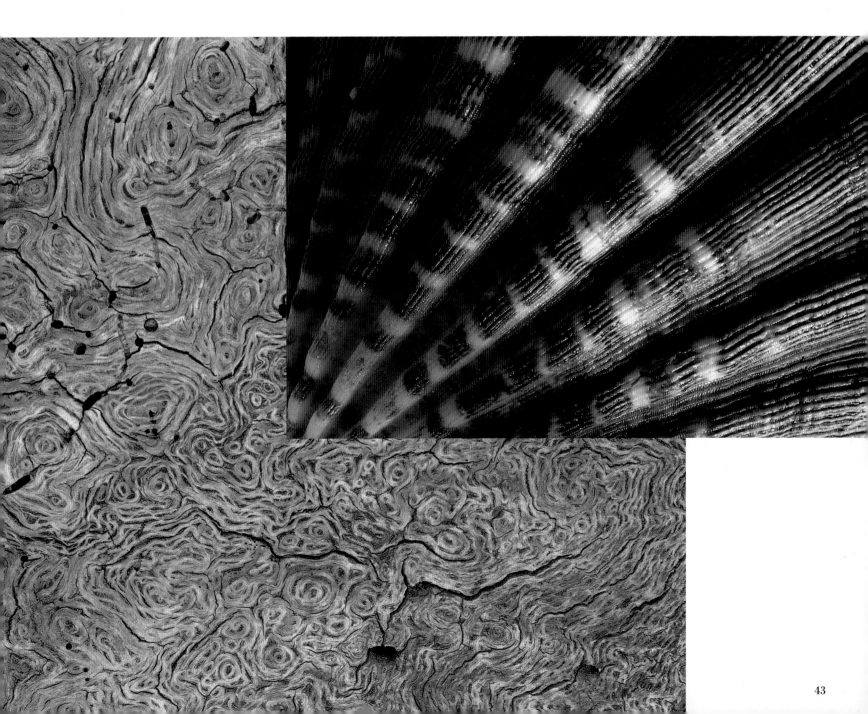

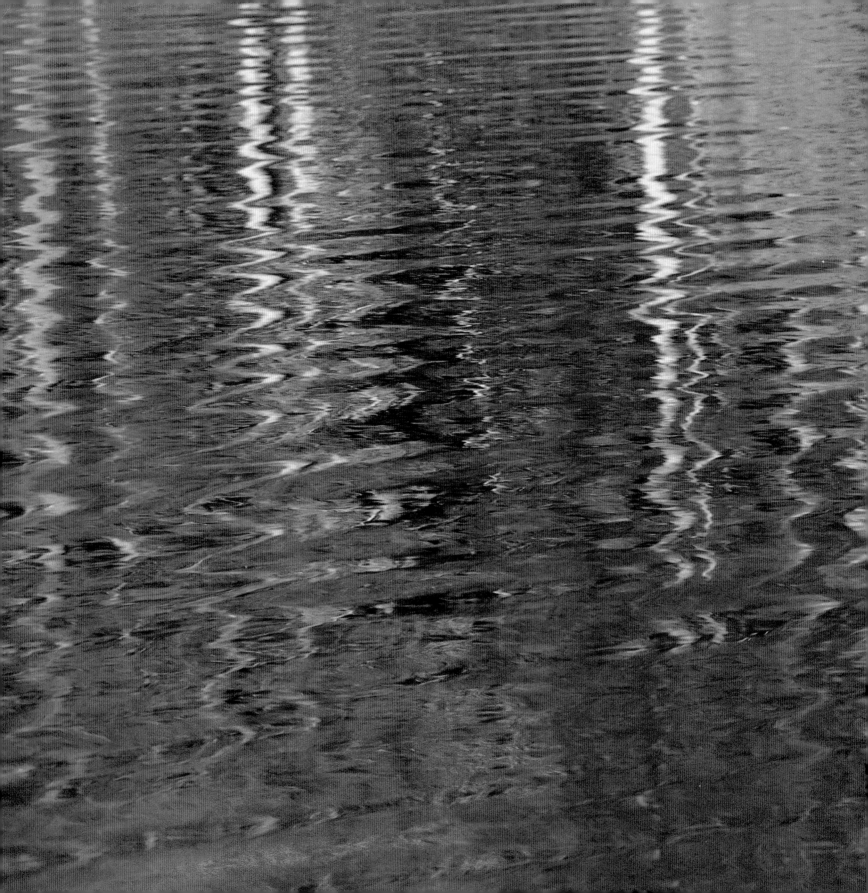

**A stone tossed in a pond** causes ripples to lap against the shore. These ripples, like other water waves, are traveling vibrations. When a wave passes through the water, the water itself isn't carried along with the wave. A stick floating on a pond bobs up and down with each passing wave, but doesn't move any closer to shore.

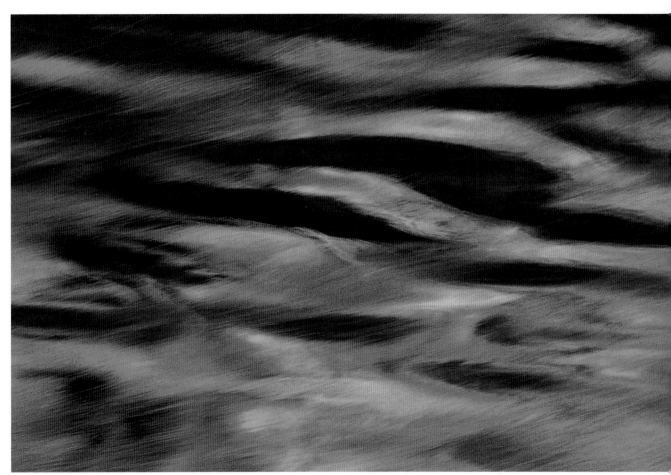

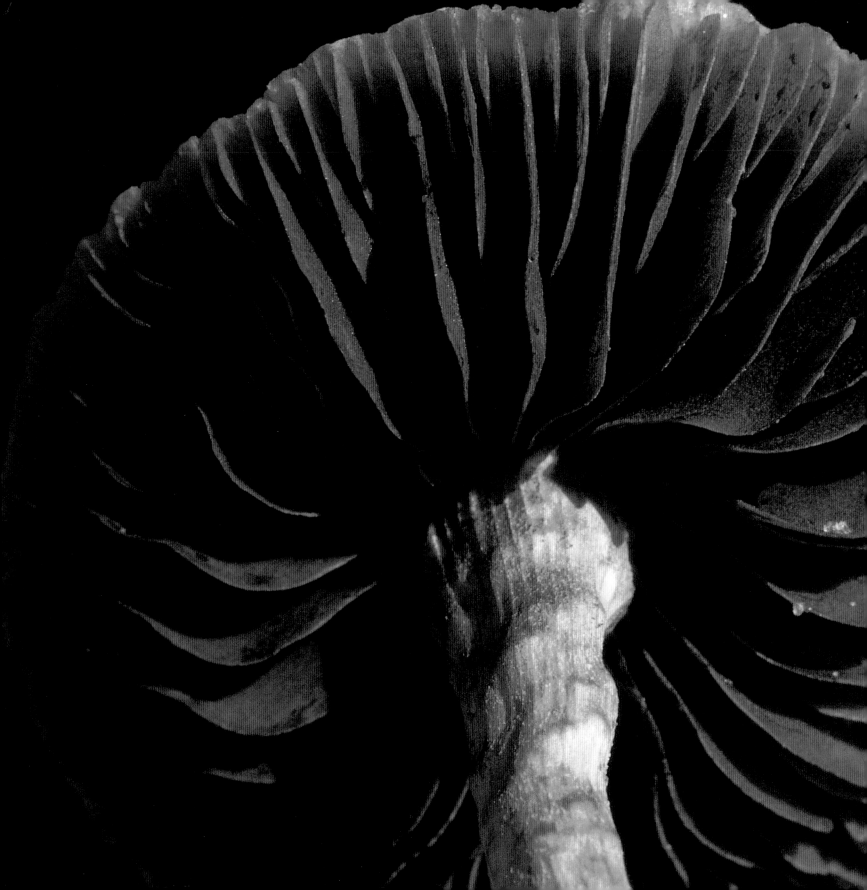

# Spheres and Explosions:

## Patterns of Perfection

# Spheres and Explosions:
## Patterns of Perfection

**To the ancient Greeks, the circle and its three-dimensional counterpart, the sphere, were perfect symbols of the divine. That's not surprising, considering the importance of spheres and circles in nature.** You began your life as a spherical egg cell. The planet on which we live is approximately spherical, as is the sun that makes life on this planet possible. A soap bubble floating on a spring breeze forms a sphere; a cat curls into a ball to sleep on a cold night. The sleeping cat curls into a ball because this shape offers the least surface area. The cat curls up to minimize heat loss—the less surface the animal exposes to the cold air, the less heat she loses. Many animals also curl up in self-defense, presenting the smallest possible surface area to predators. The soap bubble forms a sphere for the same reason—the least surface area for the most volume. The spherical soap bubble forms because the inward pull of the elastic bubble film is opposed by the outward push of the air inside the bubble. The balance between these forces creates a sphere, the shape that provides the most space for the air with the least stretching of the bubble film. A spherical balloon filled with water can be forced to undergo a rather

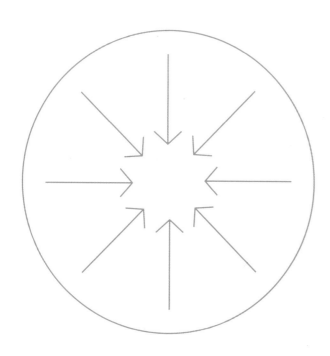

The balance between inward
and outward forces creates a sphere.

abrupt transition. Drop the balloon from a height, and you'll create an explosive pattern —a splash of water radiating out from the center in all directions. You can see an echo of the water balloon's splash in the petals of flowers, the tentacles of a sea anemone, the arms of a sea star, or the spines of a sea urchin. In all these explosive patterns, lines fan outward from a central point to cover a large area. Each radiating line in an explosive pattern provides a direct path —the shortest possible path—back to the center of the explosion. |A look at a sea anemone reveals some of the advantages of the explosive pattern. One end of this marine animal's cylindrical body is anchored to the sea floor; the other end has a radiating pattern of tentacles surrounding the animal's mouth. The sea anemone spreads its tentacles to collect food from a large volume of water. The tentacles transport food to the animal's centrally located mouth by the shortest route possible. |Of course, if the sea anemone is attacked, its explosive pattern becomes a liability —the radiating tentacles are difficult to protect. When the anemone is disturbed, the animal draws its tentacles into a tight ball to minimize its surface area —returning to an approximation of a sphere.

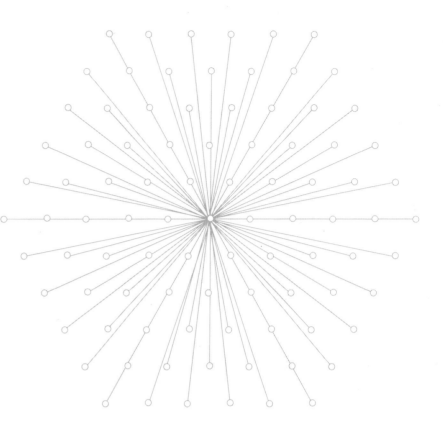

Explosive pattern

49

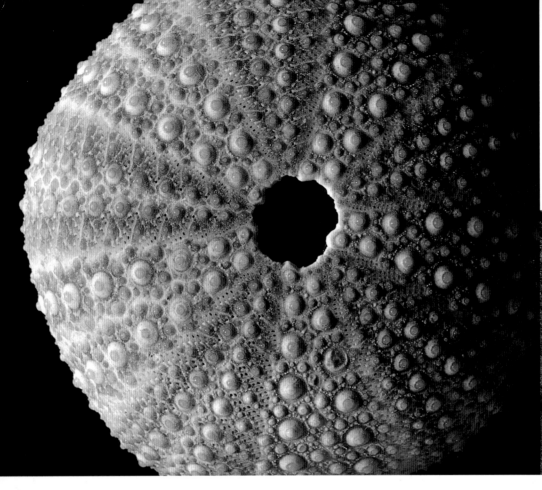

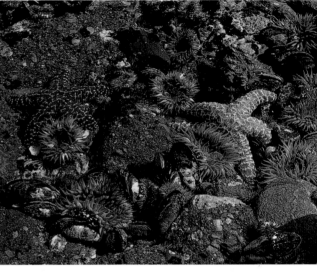

SEA URCHIN SHELL

The skeleton of a sea urchin is a slightly flattened sphere. This shape minimizes the surface area that the animal exposes to predators and simultaneously distributes the stress of gravity uniformly, so that the shell is less likely to crack at any one spot. In the living urchin, the shell supports spines and tube feet that radiate outward.

Like the flower for which it was named, the sea anemone is anchored in place. Outstretched tentacles are covered with stinging cells that stun the fish on which the animal feeds. The tentacles contract to bring the food to the anemone's mouth, which is in the center of the circle of tentacles. Many animals that have a radiating pattern tend to be slow-moving, like the sea star, or anchored in place, like the anemone.

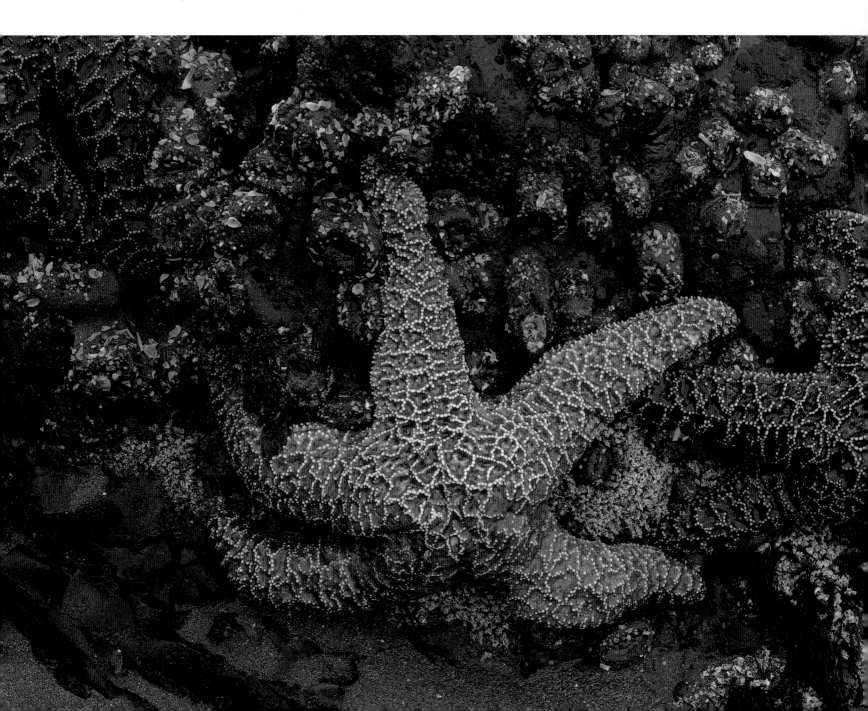

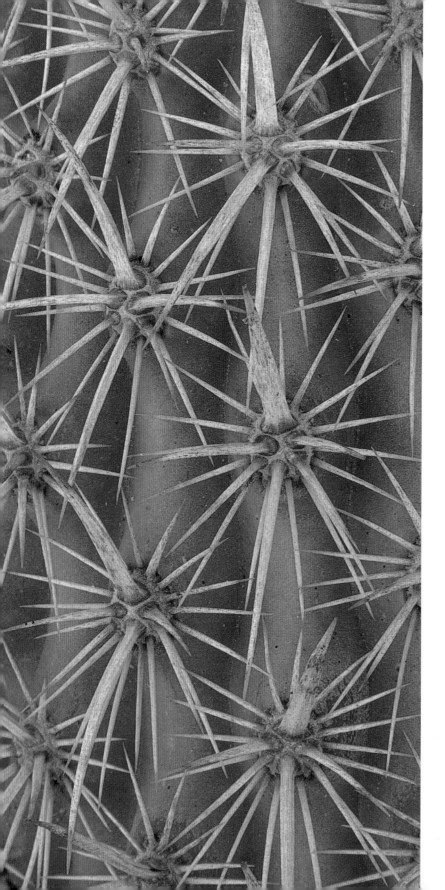

## CREEPING DEVIL CACTUS

The spines of the creeping devil cactus form a regular array of starbursts. Each spine-producing patch on the cactus's skin produces a single daggerlike central spine and twenty smaller spines that fan out in all directions. The pattern of starbursts provides maximum protection for the plant's vulnerable skin. Not only do the spines fend off hungry animals, but they also help the plant minimize water loss. The spines shade the plant's skin, reflect the sun's heat, and slow breezes blowing near the skin, keeping them from carrying away moisture.

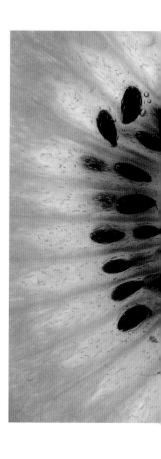

These raindrops, suspended on the fuzzy surface of lupine leaves, form glittering spheres. The attraction of one water molecule to its neighbors pulls the drop into the shape that provides the most volume with the least surface area. The lupine on which the dewdrops rest forms starburst patterns, with each group of leaves radiating outward from a central point.

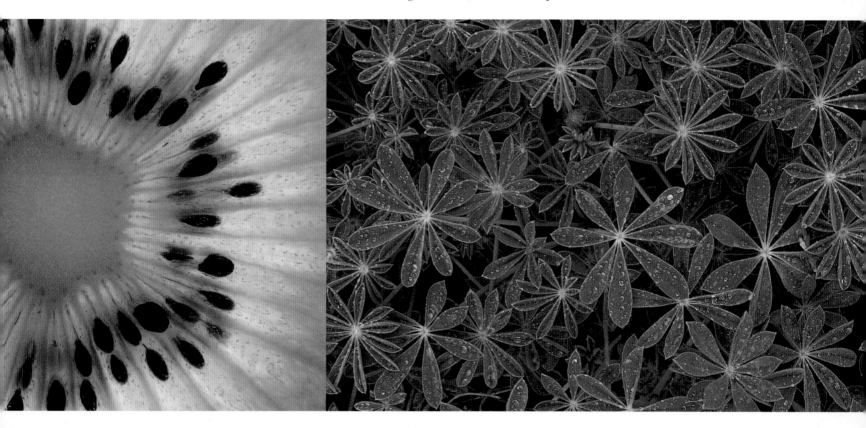

KIWI FRUIT

A slice of kiwi fruit displays the starburst pattern at the center. Often, the pattern of seeds echoes the flower that produced the fruit. An apple blossom, for example, has five petals and five ovaries containing unfertilized seeds. Slice an apple and you'll find these five seed compartments, arranged in a starburst.

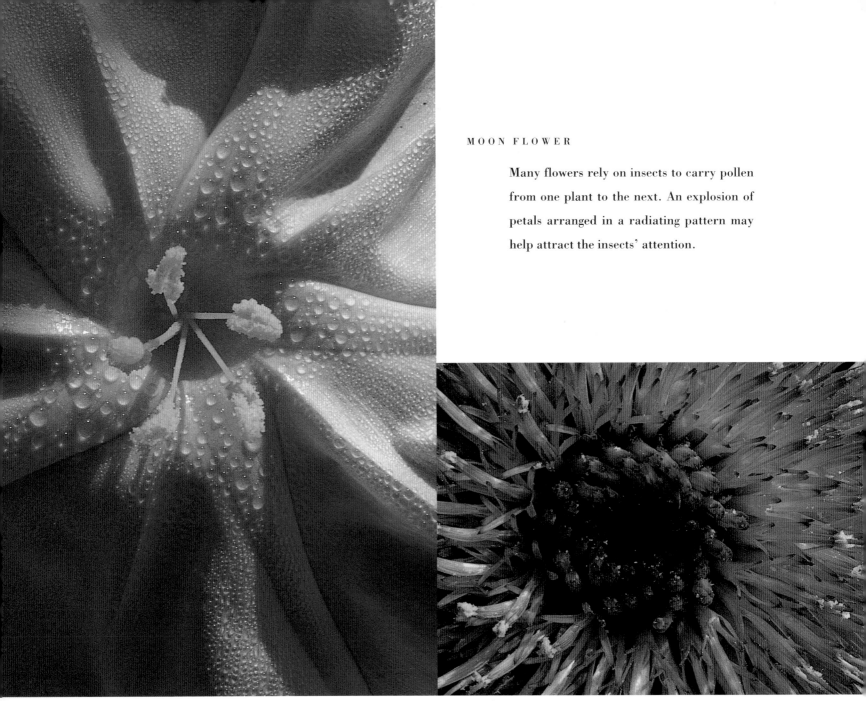

MOON FLOWER

Many flowers rely on insects to carry pollen from one plant to the next. An explosion of petals arranged in a radiating pattern may help attract the insects' attention.

THISTLE FLOWER

BUNCHBERRY DOGWOOD

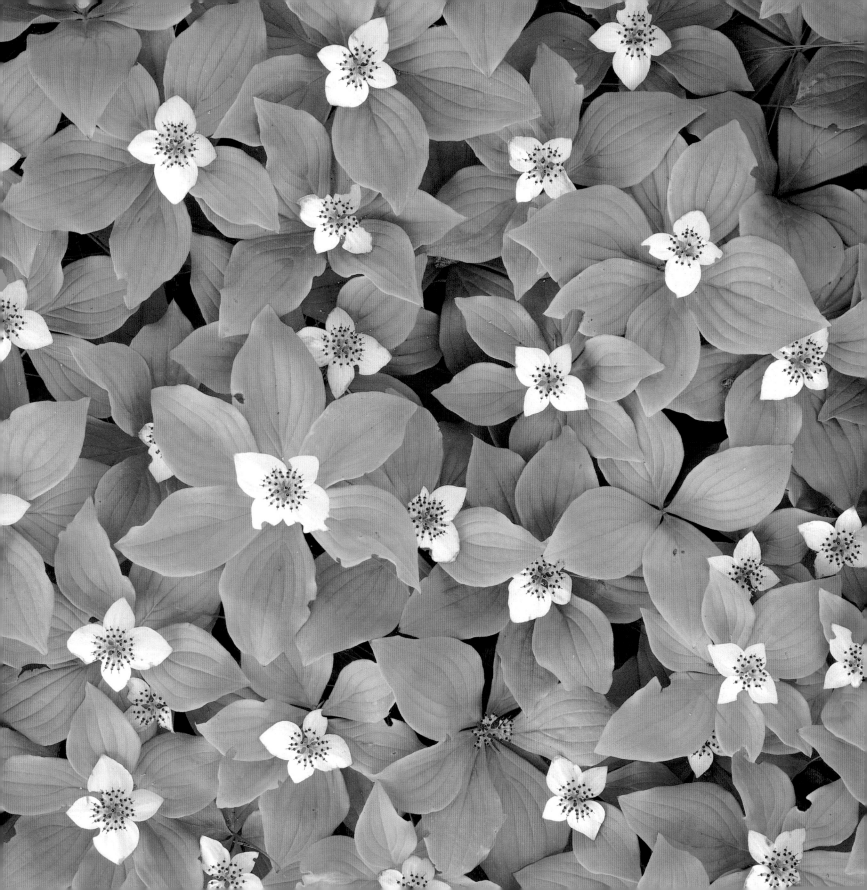

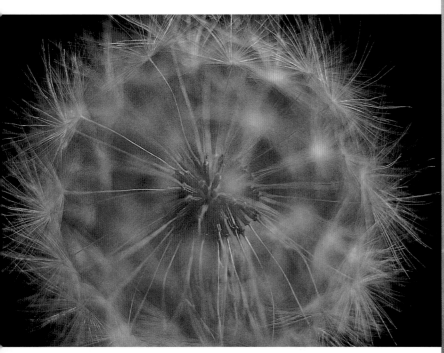

SALSIFY FLOWER *gone to seed*

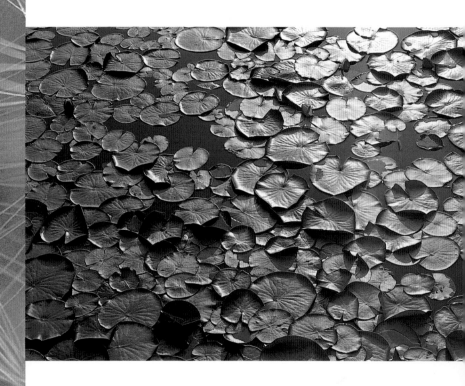

After the petals of the salsify flower have withered and died, the seeds open to form a delicate sphere. If you look closely, you'll see that each seed echoes the pattern of the whole—at the end of each seed there's a radiating tuft of downy fibers that helps the seed float on the breeze.

SALSIFY SEEDS

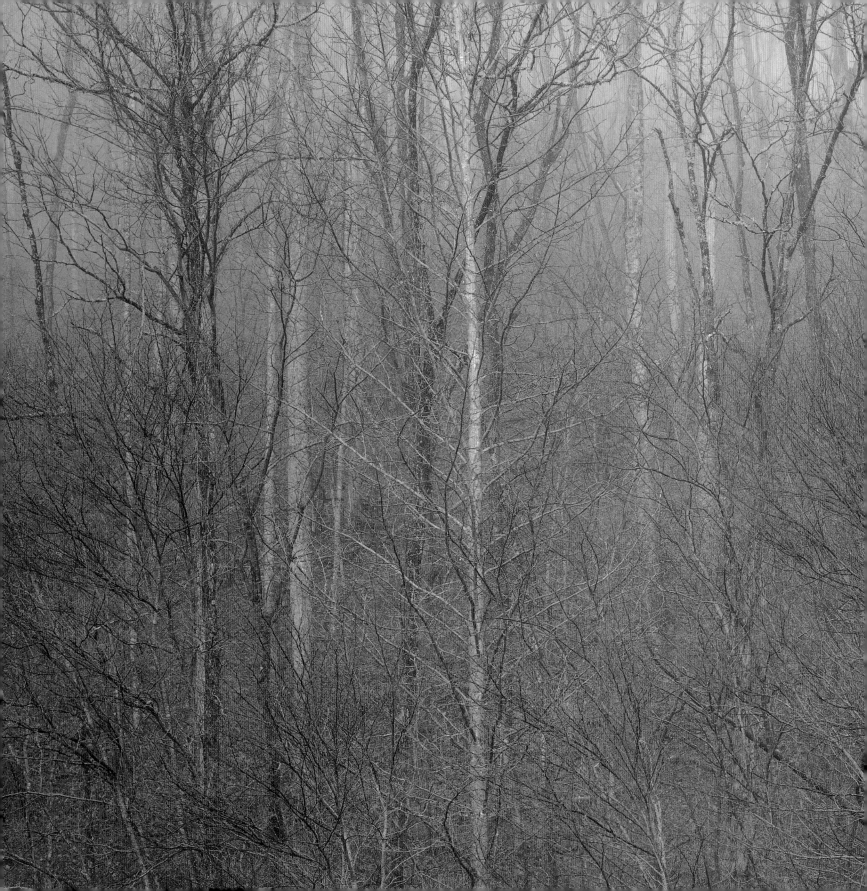

# Branching: An Elegant Compromise

# Branching: An Elegant Compromise

At first glance, a forest may appear patternless, a random tangle of branche and leaves. But within this apparent jumble i hidden regularity. Consider a single tree. Start a the trunk and work your way up to the canopy o leaves. The trunk gives rise to large branches; th large branches support smaller branches; thos branches, in turn, sprout twigs. Examine a leaf, and you'l find more branching: One leaf vein flows into smaller veins which split into even smaller ones. Work downward from the tree's trunk, and you'll find the intricate branching of the root system. Branching patterns often form where fluid flows in from a large area to a central point. In the roo system of a tree, for example, the roots branch out to gather minerals and water from the soil. In a river system, falling rain forms trickles, which join to make streams, which then feed into larger streams and rivers. Branching patterns also appear where fluid flows out from a central point to cover large area. Sap flows from the central tree trunk through

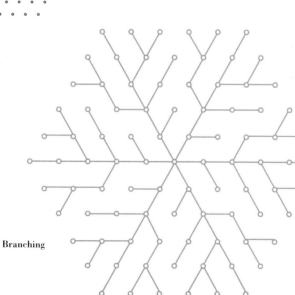

Branching

Starburst

Spiral

Meander

smaller and smaller branches to reach a canopy of leaves. The blood vessels in your body echo the same pattern as they conduct blood to all your cells. | A branching pattern is an efficient way to reach all the points in a large area, while moving along the shortest possible distance. You can demonstrate this by trying different methods for connecting dots. Suppose you wanted to draw a line that connected the center dot in a group of dots with all the other dots. You could start with your pencil on the center dot and draw a line that spirals outward to touch each dot. Or you could start at the center dot and draw a line that meanders from dot to dot until you've connected them all. In both cases, the dots are connected by a very indirect path—your pencil has to travel a long distance from the first dot to the last one. | Rather than connecting all the dots with a single line, you could use many lines. Suppose you drew a starburst pattern of lines, with each line starting at the center and extending to the edge, connecting all the dots in its path. This pattern connects the outlying dots to the

center much more directly than the spiral or the meander— each separate path from the center to the edge is much shorter than it was in either of the other patterns. But you have paid a price for your directness: If you add up all the separate lines in the starburst, you'll find that their overall length is more than twice as long as the spiral or the meander. | The spiral and the starburst are two extremes. The spiral reaches the points with the shortest line but does so by following a circuitous path. The starburst requires a longer total line length but offers a much more direct path. Branching patterns offer an excellent compromise between the two extremes. The total length of line is much shorter than that of the starburst pattern. In fact, it can be as short as, or in a few cases even shorter than, the spiral. Yet the branching path is much more direct than the spiral—and only a little less direct than the starburst.

**Trees adapt the basic branching** pattern to match the demands of their environment. A tree's overall shape reflects the need to intercept light, radiate heat, shed snow, and withstand wind.

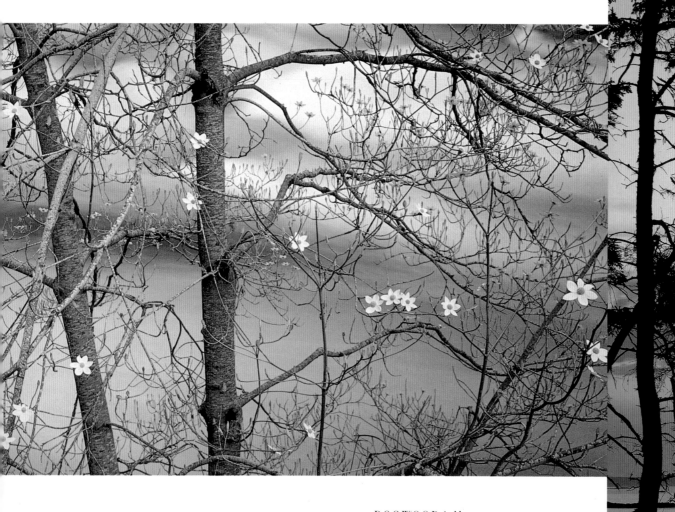

DOGWOOD *in bloom.*

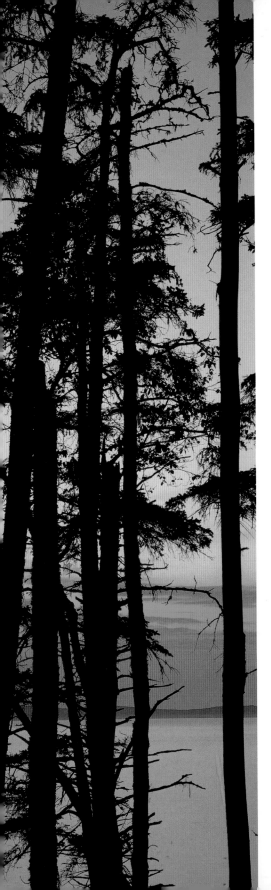

EVERGREENS

ASPEN GROVE

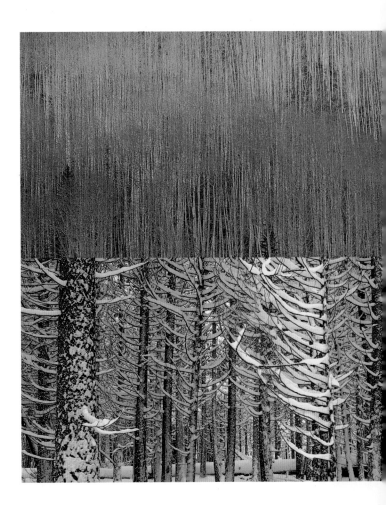

INCENSE CEDARS

# The patterns of branches can inspire poetry—and thoughts of plumbing

The tree branches reaching up to the sky are an elegant set of conduits, through which water and nutrients flow. The sizes, shapes, and directions of branches depend on both the ease of the flow and the constraints of the environment.

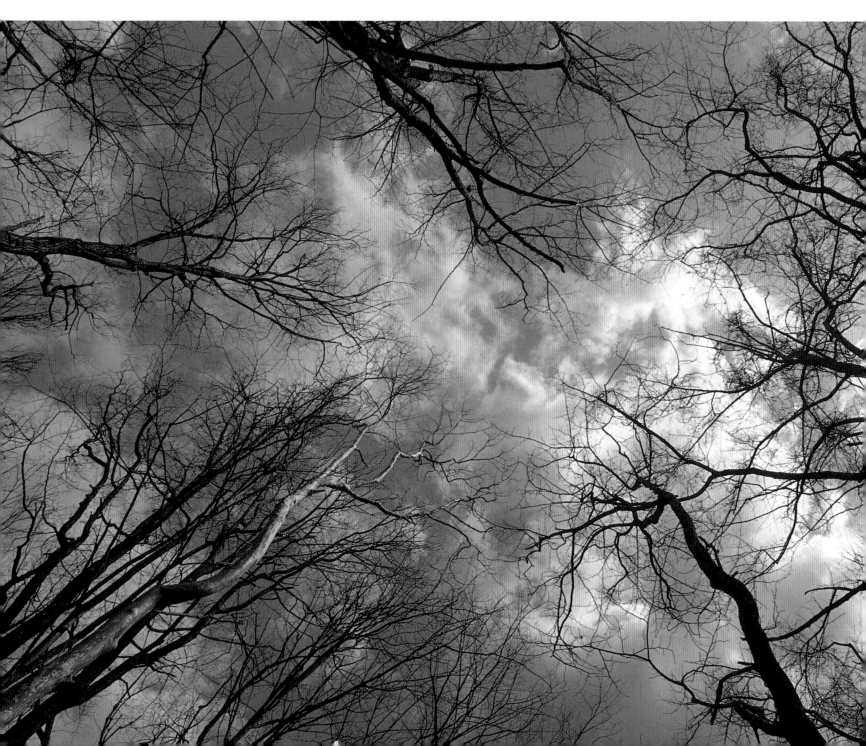

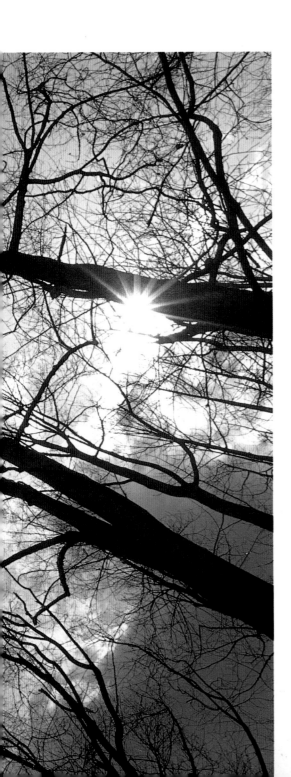

**LEAF**
*from sea grape tree*

The pattern of branching in the veins of a leaf may reveal something about the plant's history. In this sea grape leaf, small veins meet the main vein in a pattern similar to that of plants with many small leaves growing from a single stem. Over the course of this plant's evolution, a multitude of small leaves may have merged to make a single large leaf, which measures up to eight inches across.

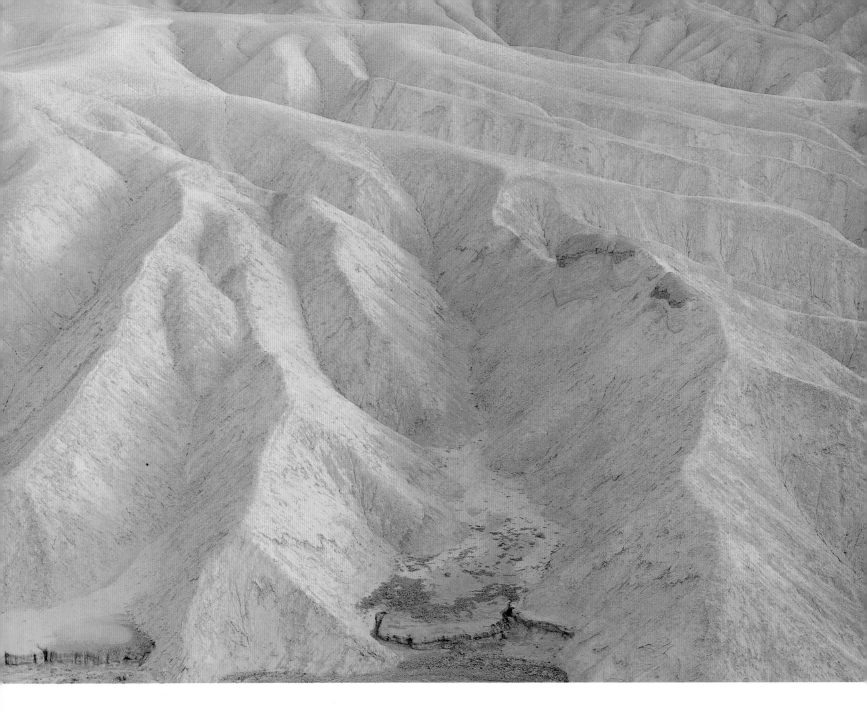

**As these erosion patterns** show, flowing water creates channels that branch like the limbs of a tree. Tiny trickles feed into streams; streams join to become rivers.

ZABRISKIE POINT
*Death Valley National Monument, California*

Suppose that a large river is fed by three smaller tributaries. Chances are that each of those tributaries is fed by three smaller streams, and that each of those streams is fed by three smaller trickles. The number of channels increases in a geometric progression as you move upstream—from rivers to streams and trickles. The same general rule holds true for the branching of trees and the branching of blood vessels in your body.

BLUE MESA
*Petrified Forest National Park, Arizona*

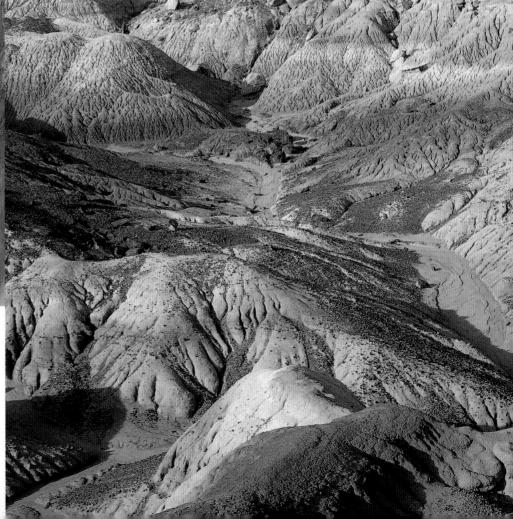

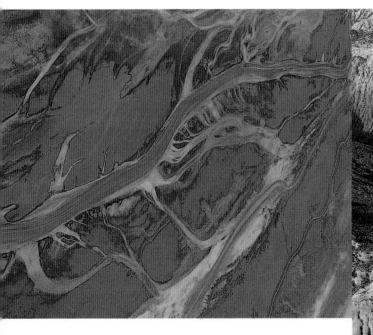

AERIAL SALT FLATS
*Death Valley National Monument, California*

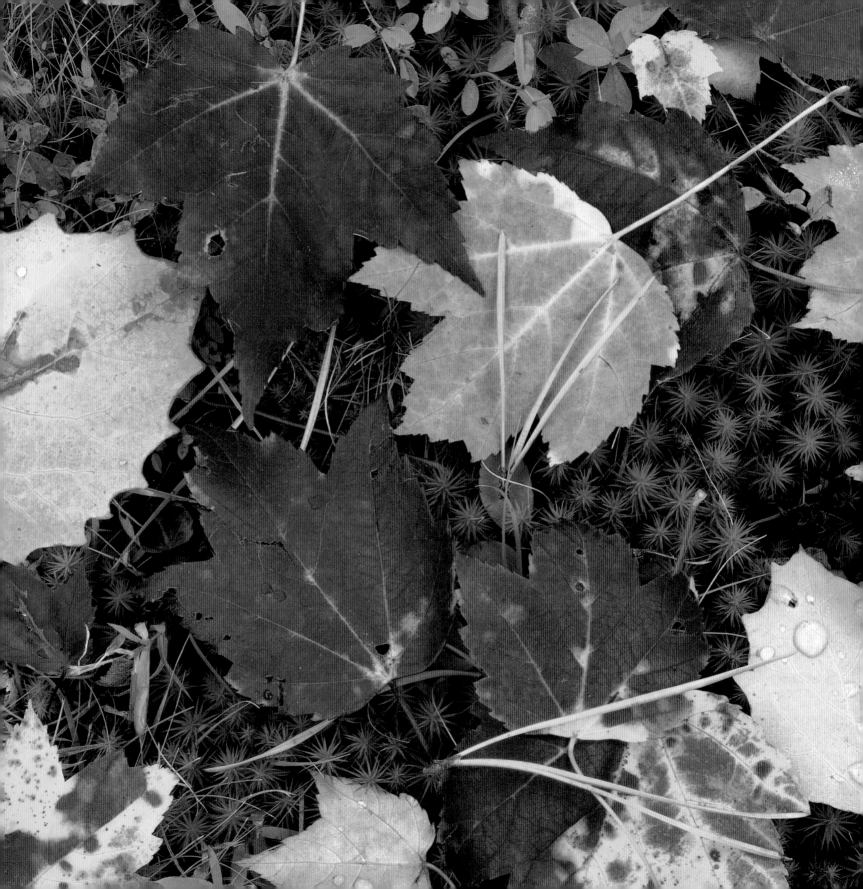

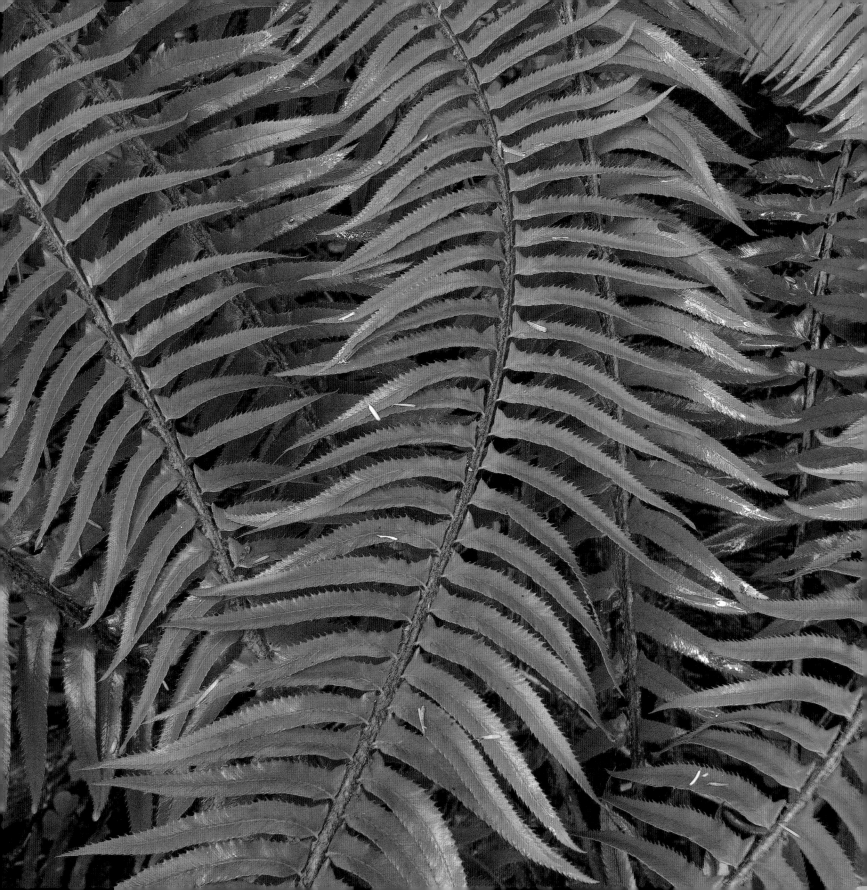

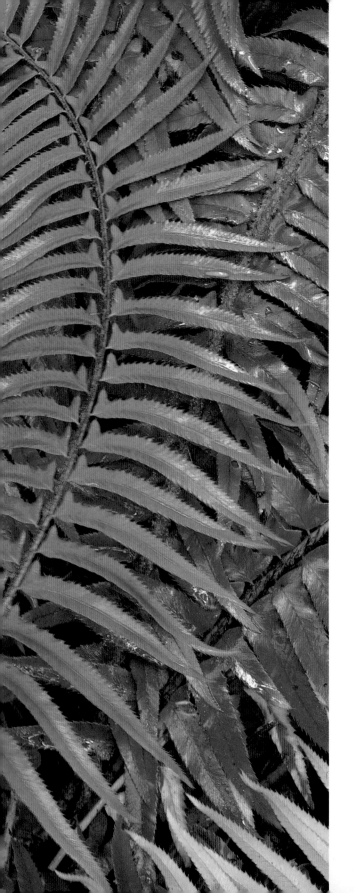

# If you look closely at a leaf, you can

see the veins that transport water and nutrients between the leaf and the rest of the plant. Paleobotanists, specialists in plant fossils, use the branching patterns of leaf veins to identify leaf fossils. Many species of plants can be identified by their leaf vein pattern alone.

JEFFREY PINE

As a tree grows, it modifies its basic branching pattern in response to environmental forces. Without adequate light, a bud does not grow into a branch. The tree responds to sun and shade and wind and snow. The resulting changes camouflage the underlying pattern.

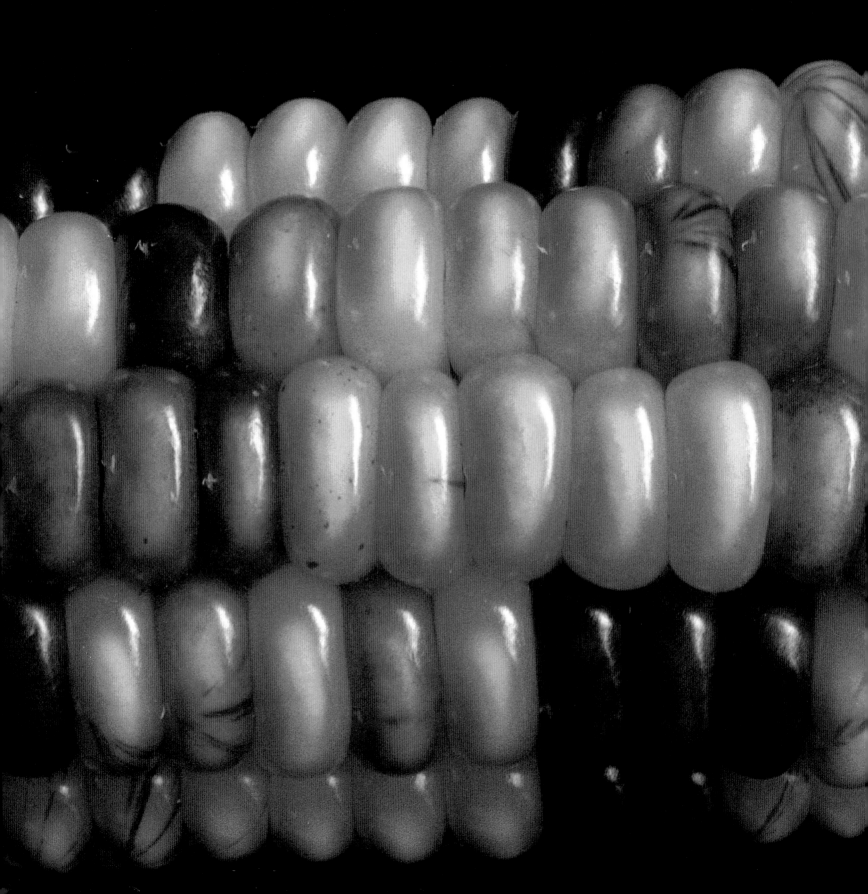

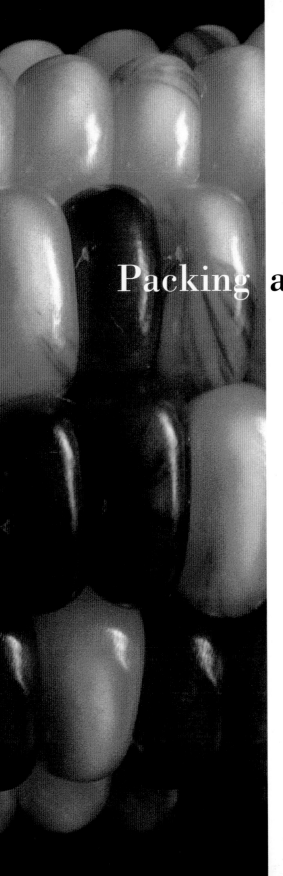

# Packing and Cracking: The Shortest Path

Nature invariably seeks the way to accomplish the most with the least—the tightest fit, the shortest path, the least energy expended. This tendency shapes the soap bubbles in your kitchen sink, the cells in a honeycomb, the kernels on an ear of corn, and the cracks in cooling lava. In all these situations, the surfaces, cracks, or partitions meet in three-way junctions at angles of 120 degrees. Why 120 degrees? You can experiment to find out. Make four dots on a piece of paper and try connecting them with lines. Measure the length of line required to connect them all. The configuration where the lines from the dots meet in three-way junctions at 120-degree angles provides the shortest path connecting the dots. In a froth of soap suds, the bubbles invariably meet in three-way junctions; the angle between the soap films is about 120 degrees. No one measures the angle and rearranges the soap

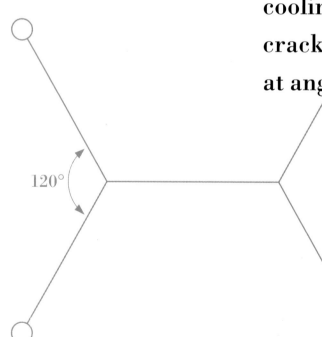

120°

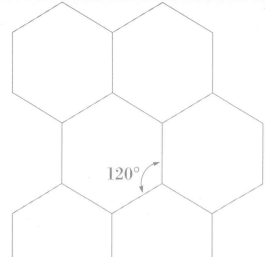

films. The bubbles pull on each other and slip and slide until they settle in this arrangement. | The thin soap films that form the bubbles are stretchy, like the rubber of a balloon. Each film is made of water, along with a little bit of soap. Because the water molecules are attracted to one another, they pull inward, trying to form the smallest possible bubble. At the same time, the air inside each bubble pushes outward. When the bubbles shift to join at three-way junctions, the inward pull of the soap film balances the outward push of the air. Since any shift away from this position makes the film stretch more, the film resists that shift. The bubble films take the position that gives them the smallest possible surface area. | The wax walls of a honeycomb—like the soap films in a froth of bubbles—meet in groups of three, forming 120-degree angles. In a honeycomb, each hexagonal cell shares its walls with six other cells in a tightly packed array. This arrangement creates a rigid structure of many small cells in which to store honey, while using as little wax as possible. | In beehives and bubble foams, in some dried lake beds and turtle shells, you can find three-way junctions at 120-degree angles. Though the mechanism is different in each situation, the principle is the same. In all these cases, the films or surfaces or cracks or cells take on the configuration that allows nature to accomplish the most with the least.

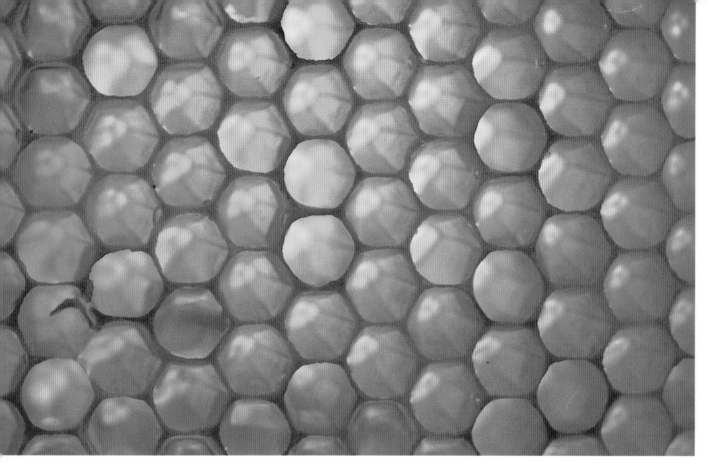

**HONEYCOMB**

An array of soap bubbles echoes the geometry of the honeycomb. The bubbles meet in threes to form 120-degree angles, the arrangement that minimizes the stretching of the soap film.

**To make a single gram of beeswax,** a honeybee consumes over sixteen grams of honey and an undetermined amount of pollen. Bees construct honeycombs according to a design that minimizes the use of this metabolically expensive commodity. The wax walls of the honeycomb's cells come together in threes at 120-degree angles, forming a regular array of hexagons. This pattern lets the bees minimize the amount of wax they use, while providing a rigid structure in which to store honey.

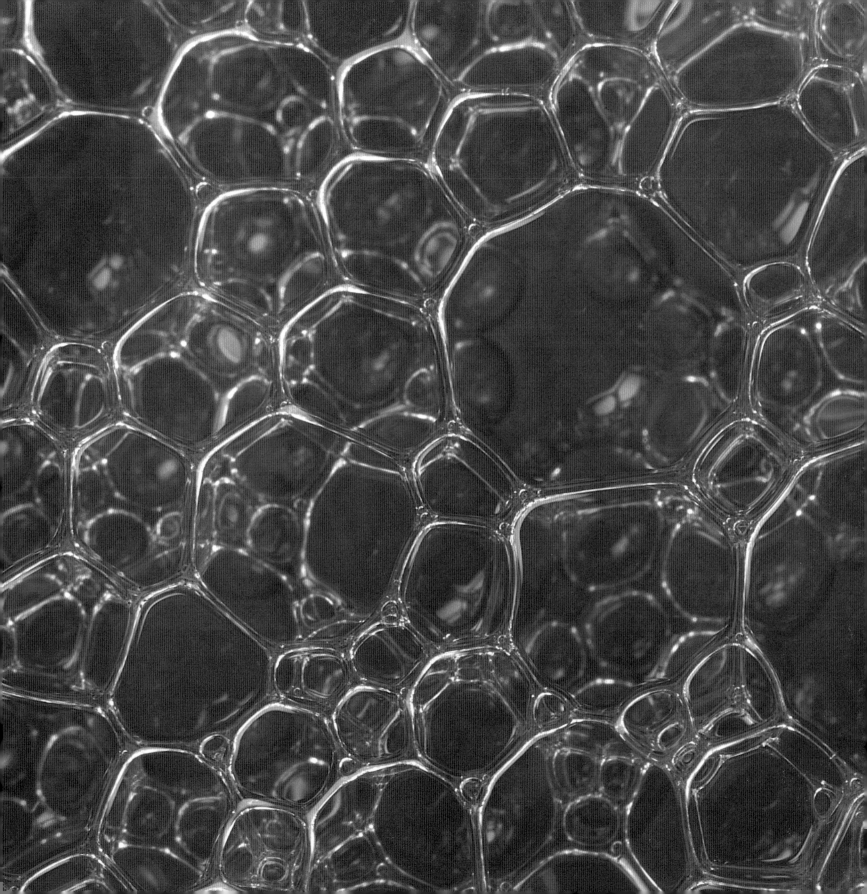

**Pebbles at the beach** shift and slide until they pack tightly together. One pebble is unlikely to balance neatly on another—it would probably tumble under the pull of gravity and nestle into a valley between neighboring pebbles. If you had a collection of identical round pebbles stacked in layers, the pebbles in the second layer would roll into the valleys between the pebbles in the first layer, forming a regular pattern. Remember the pattern of pebbles on the beach the next time you eat an ear of corn.

PEBBLES *and eroded sandstone*

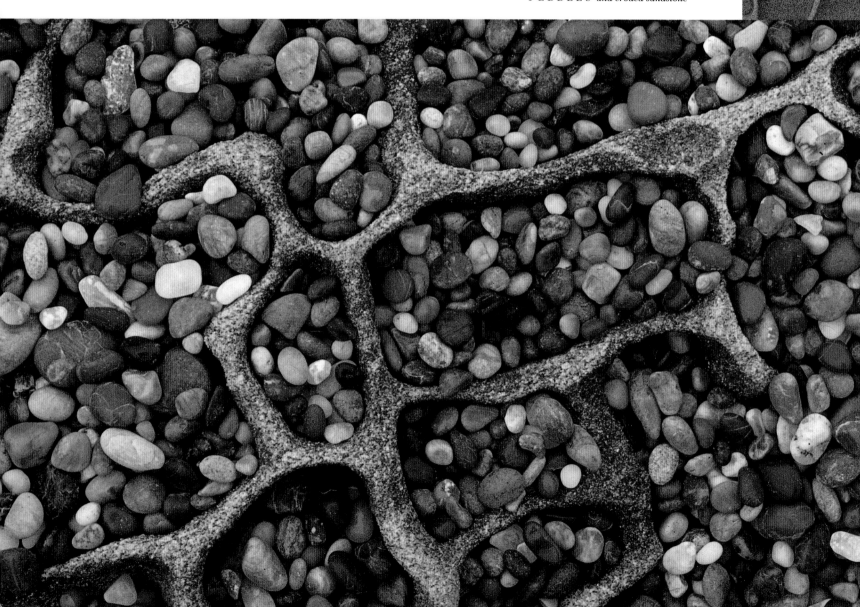

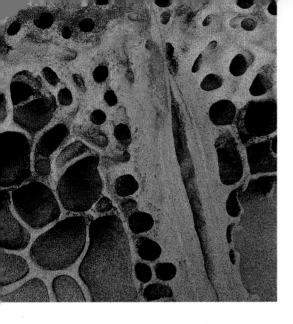

ROCK FORMS

On an ear of corn, the rows of kernels are staggered, so that the kernels on one row fit neatly into the gaps between the kernels in the neighboring row. Notice that the gaps between the kernels meet in threes—like the soap bubbles and the wax walls of the honeycomb. Wherever you see tight packing of identical objects, look for this three-way junction.

INDIAN CORN

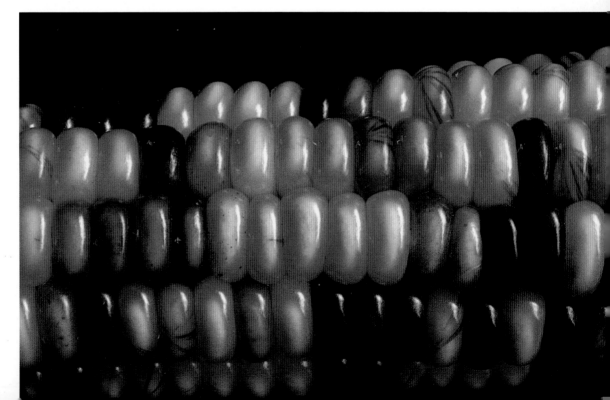

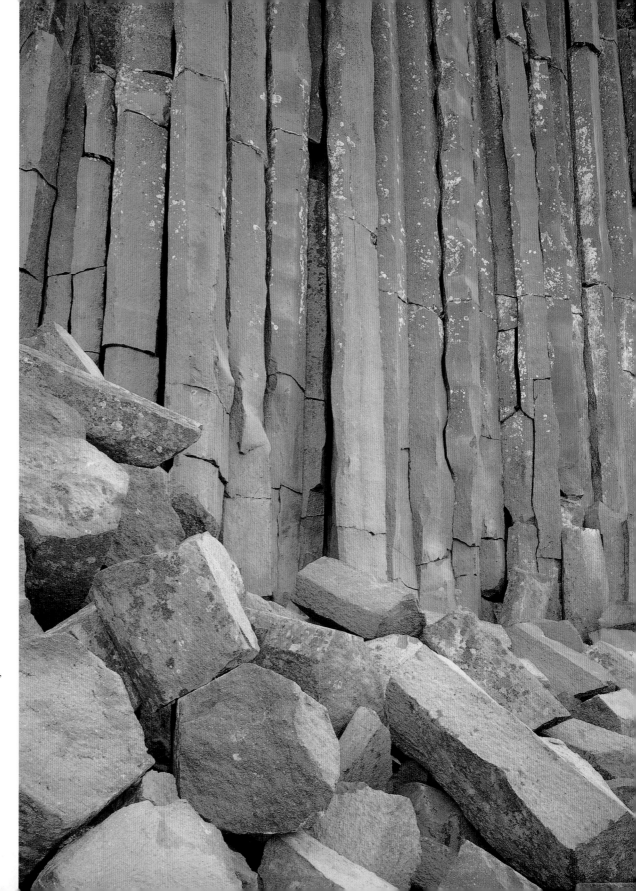

BASALT COLUMNS
*viewed from side,*
*Devil's Postpile National Monument,*
*California*

# When the molten basalt that formed

Devil's Postpile cooled, it began to crystallize. As the rock crystallized, it shrank. This shrinkage created stress within the block of basalt—and the basalt cracked to relieve that stress. It takes energy to crack rock, but the shorter the crack is, the less energy required to make it. On top of Devil's Postpile, you can see that cracks meet in groups of three to form angles of about 120 degrees—a geometry that matches that of the honeycomb. This pattern of hexagons relieved the most stress with cracks of the shortest length. Whenever a slab of uniform material shrinks, the cracks that relieve its stress form 120-degree angles. The cracks on top of Devil's Postpile extend deep into the basalt, forming tall hexagonal columns.

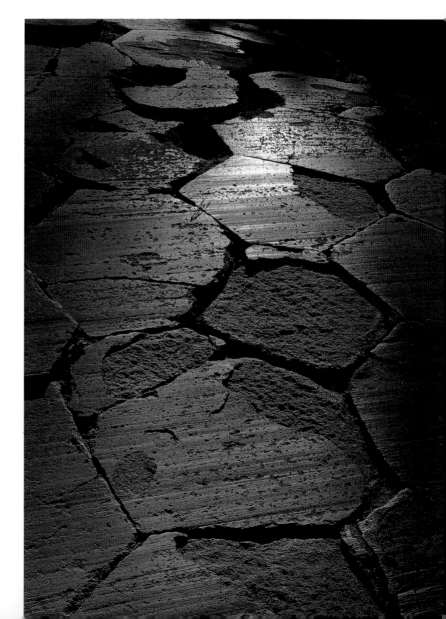

BASALT COLUMNS
*viewed from top,*
*Devil's Postpile National Monument, California*

CRACKED ROCK

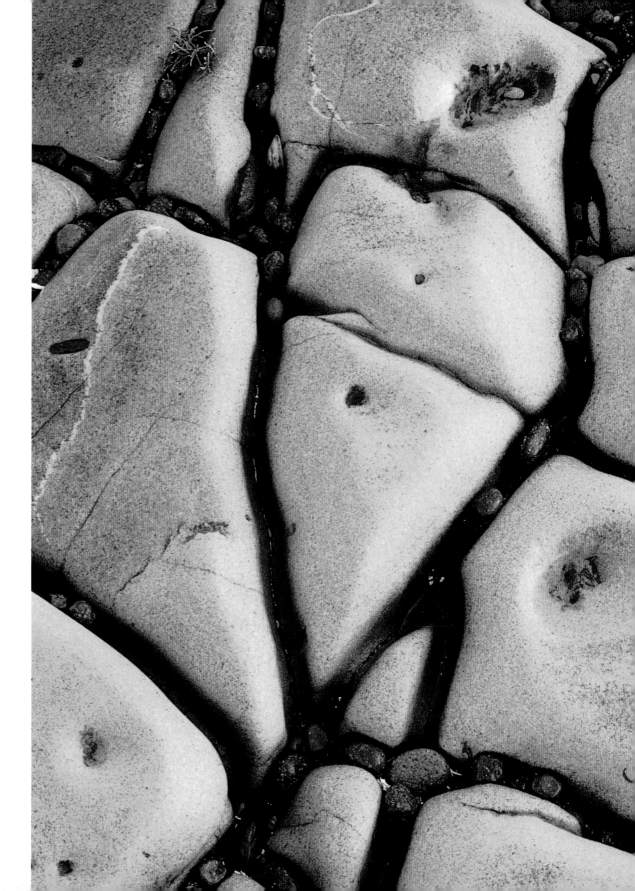

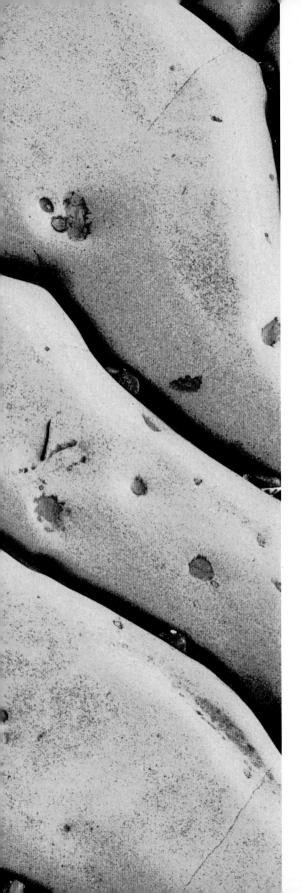

# When you see cracks in a rock,

look carefully at the patterns they form. By examining these patterns, you can tell whether the cracks formed sequentially or all at the same time.

Most of the cracks in this rock meet at right angles. Long ago, movements of the earth caused the rock to fold or bulge. The first crack formed where the stress was greatest or the rock was weakest. Once that crack started, it kept going— just as a small tear in a piece of paper easily becomes a bigger tear. That first crack relieved forces trying to stretch the rock in one direction. After that, any new crack in the rock formed along the line of greatest tension—perpendicular to the first crack. When you see a pattern in which most of the cracks meet at right angles, you know that the cracks formed sequentially, rather than all at the same time. The triangular shapes breaking up the grid may have been caused by another fold in the rock along a different line.

Compare this pattern with the pattern of hexagons in the basalt of Devil's Postpile National Monument. The basalt cooled uniformly and all the cracks formed at about the same time, relieving the stress with the shortest possible set of cracks.

MUDCRACKS AND SAND DUNES *at twilight*
*Death Valley National Monument*
*California*

**As mud dries, it shrinks.** No longer able to fill the same space, the mud cracks. Notice that most of these cracks meet at right angles, an indication that they were formed sequentiallly, rather than all at once.

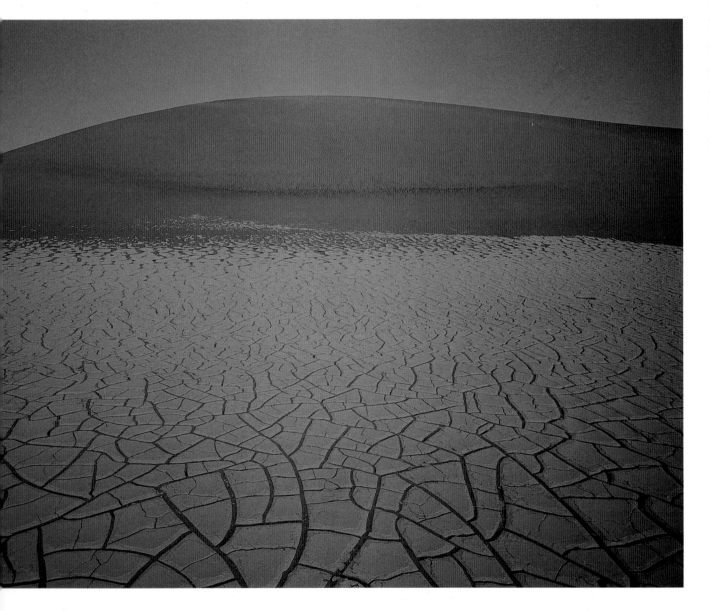

SALT FLATS
*Death Valley National Monument*
*California*

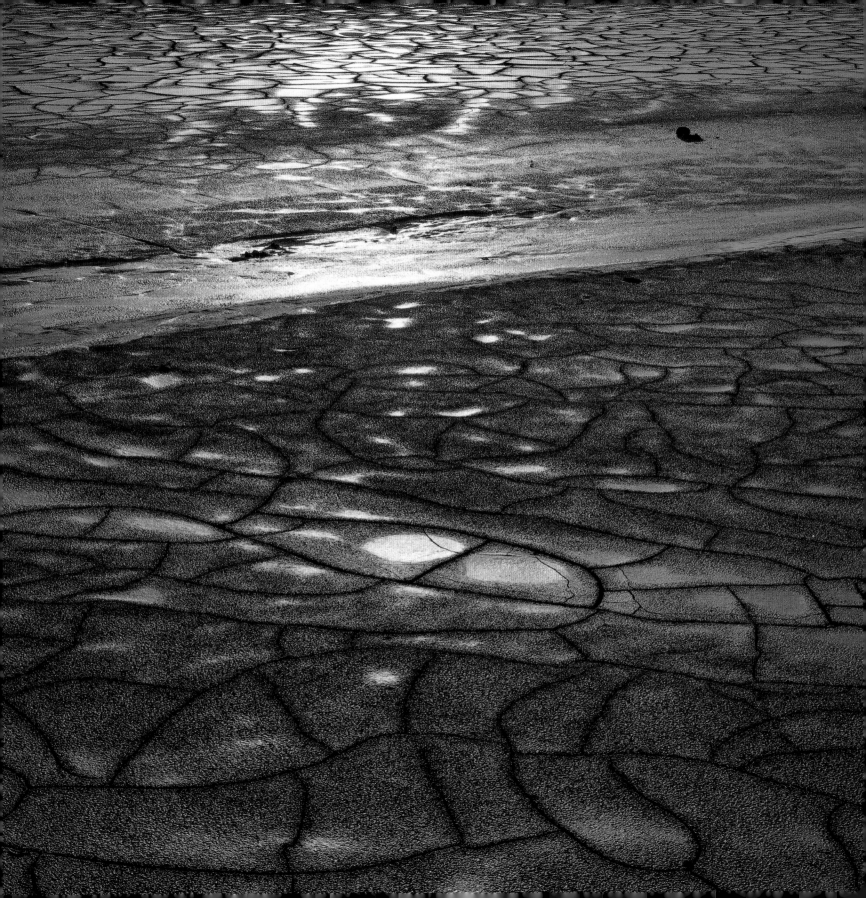

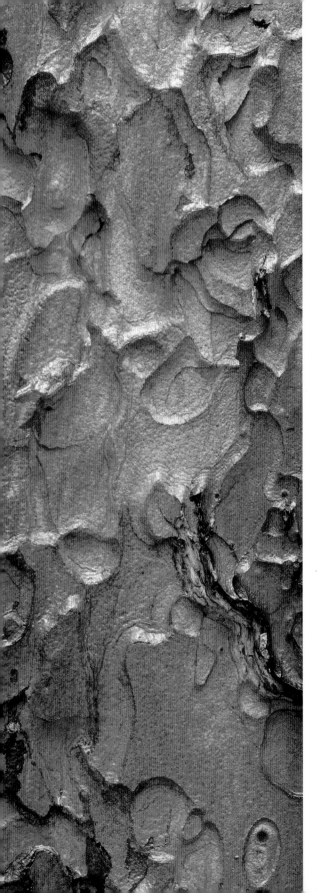

As a tree grows, its bark splits to accom-
modate the expansion of the tree's trunk—
but the bark doesn't crack in neat hexa-
gons like the basalt of Devil's Postpile.
The molecular forces that hold together a
slab of basalt are more or less uniform in
all directions. By contrast, the forces that
hold together the molecules that make up
bark are not uniform—the molecules
are more difficult to split apart in some
directions than they are in others. As a
result, the cracking of tree bark forms
more complex patterns than the cracking
of rocks.

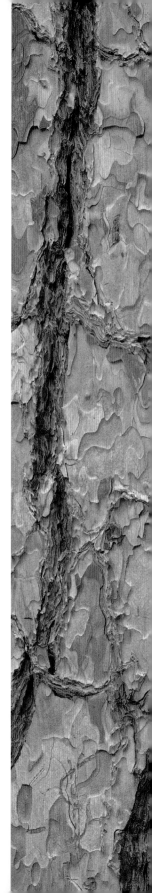

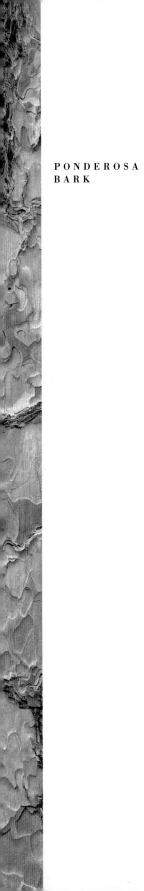

PONDEROSA
BARK

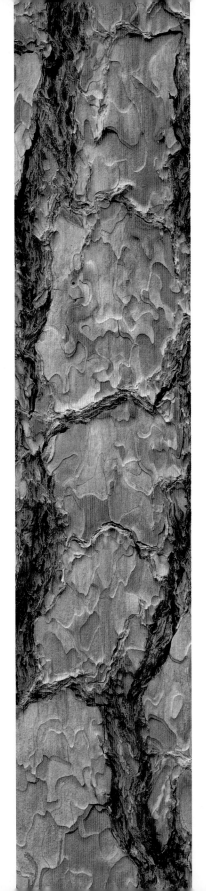

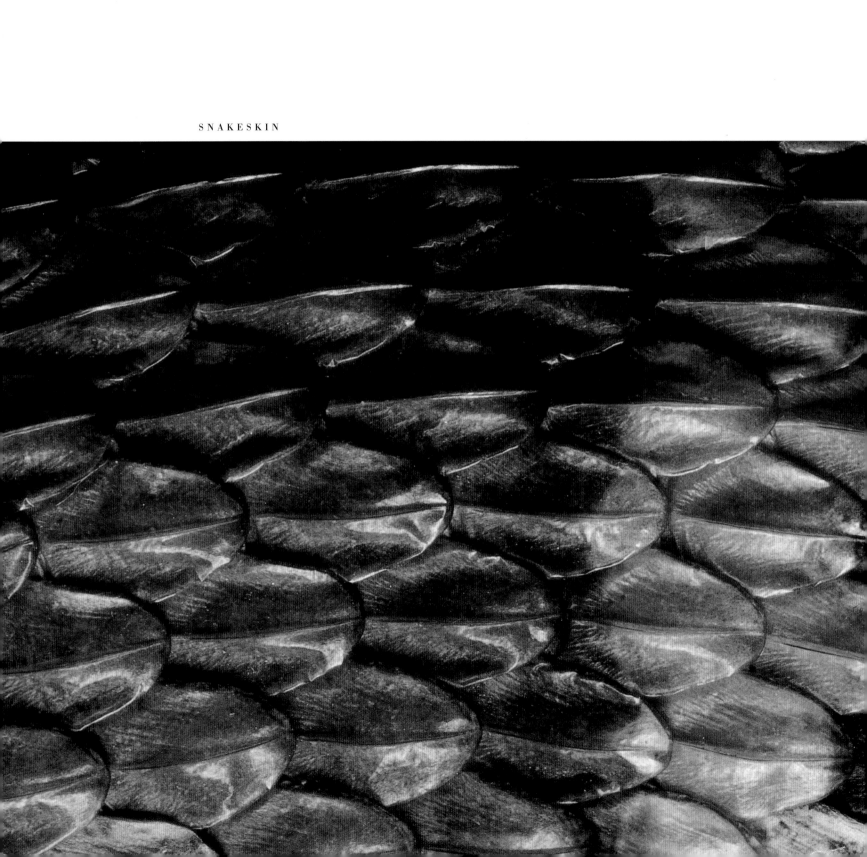

**Similar patterns appear** in a variety of contexts.
The edges of the scutes on a turtle's
shell and the scales of a snake's skin
form three-way patterns reminiscent
of soap bubbles and cracking mud.

TURTLE SHELL

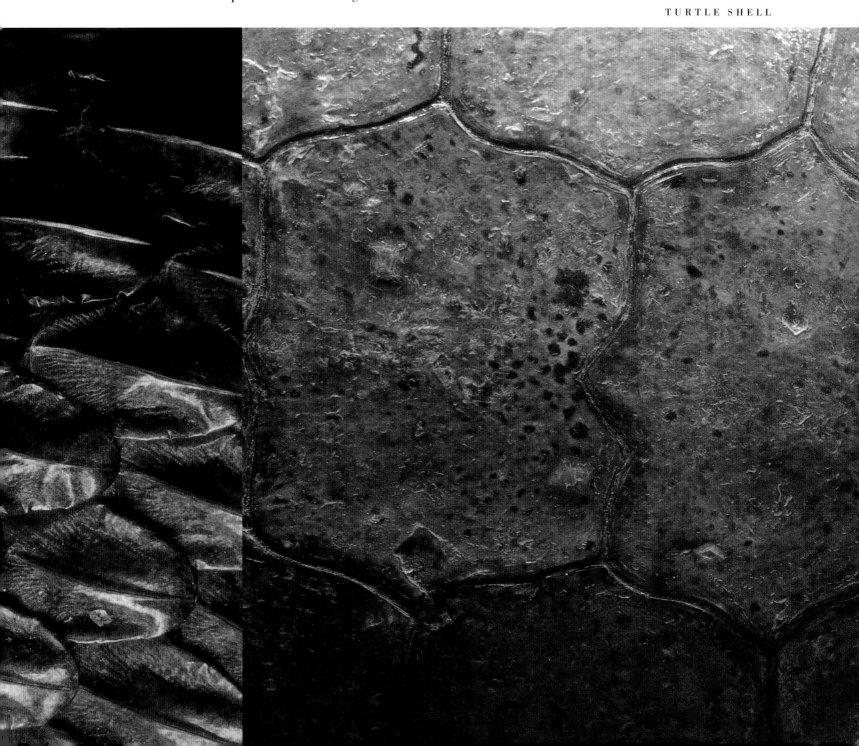

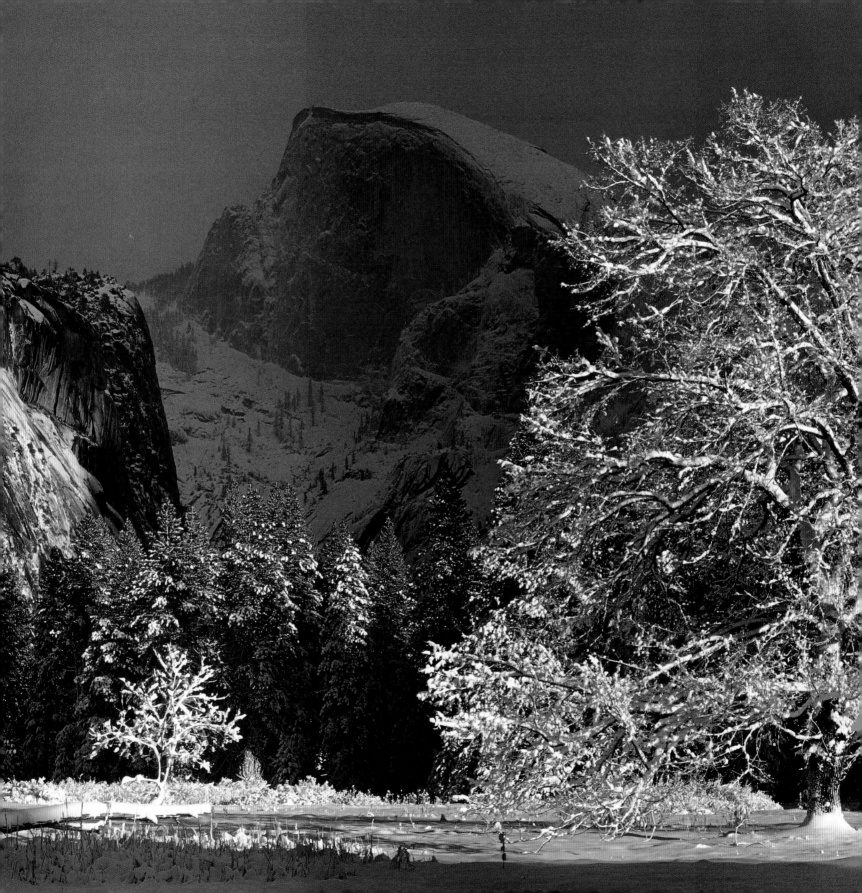

# Fractals: A New Geometry

# Fractals: A New Geometry

**How can you precisely describe the cragginess of a mountain peak, the billows and whorls of a cloud, or the intricate branching of a tree?** Classical geometry—with its smooth curves and straight lines—can't accommodate the irregularities of the natural world. In the mid-1970s, Benoit B. Mandelbrot, a mathematician at IBM's T. J. Watson Research Center, developed a geometry that could analyze and quantify nature's crags, whorls, billows, and branchings. He called this new branch of mathematics *fractal geometry*, taking the name from the Latin adjective *fractus*, which means "fractured, fragmented, or broken." Since that time, scientists and mathematicians have used fractals to find order in natural structures that previously defied analysis. Not every irregular shape is fractal. To fit into this category, a shape must have what Mandelbrot called *self-similarity*—the details must look much like the larger picture. A rocky coastline is one classic example of a fractal pattern. Take an aerial photograph of coastline, then magnify a section of that photo ten times. The result will still look like a coastline—a wiggly line with bays and headlands. Magnify a section of the enlarged view, and what you get will still resemble the original full-scale view. Over many levels of magnification, the jagged line of the coast

will look much the same. Attempting to measure the length of that same coastline reveals another characteristic of fractals. When it comes to fractals, length is not a simple measurement—the length of a fractal depends on the size of the yardstick you use to measure it. Suppose you measured the coastline on a satellite photo. You'd get one answer. If you traveled the length of the coast on your hands and knees with a ruler, you'd get a larger number—because you measured tiny bays that were not visible on the satellite photo. If you tracked the path of an ant that followed each tiny irregularity in the coast, you'd get a still larger number. Coastlines—like other fractal shapes—have wrinkles on wrinkles on wrinkles. Their length depends on the size of the wrinkles you're measuring. Mathematicians have come up with a system to use in talking about fractals. To quantify how wrinkly or irregular a fractal is, mathematicians give it a numerical value known as its *fractional dimension*. Basically, the fractional dimension is a way of expressing how well a particular shape or line fills up space. Mathematicians say that a straight line has one dimension, a flat plane has two dimensions, and a solid shape has three dimensions. A wiggly line, like the line on a map that designates the California coast, is assigned a fractional dimension of about 1.3—it fills up more space than a straight line, but it doesn't really fill a flat plane. If the coast were wigglier, it would have a fractional dimension closer to 2; if it were straighter, the fractional dimension would be closer to 1. Analysis of the fractal geometry of natural forms has led to the creation of fractal forgeries, computer-generated images that resemble the forms of the natural world. A computer generates a fractal image in much the same way a mason builds a stone wall. The mason's instructions could be summarized very simply: Lay down a line of bricks; lay down a line of bricks on top of the previous line, offset by half a brick; repeat until done. At the heart of any computer-generated fractal is a similar mathematical formula. The computer makes a calculation and plots a point, then plugs the result of the first calculation back into the formula and repeats the calculation. Hundreds of thousands of calculations create a fractal image. The precise image depends on the mathematical formula employed. Using different formulas, computers have generated images that resemble landscapes, clouds, and trees. These creations demonstrate that complex structures that appear to be irregular can be generated by means of simple repetition at scale after scale.

Each frond in a thicket of ferns
sprouts miniature copies of itself.
Those copies, in turn, sprout even
smaller versions of the same basic
shape and structure. This repeated
duplication on ever smaller scales is
called *self-similarity*, a characteristic
of fractals.

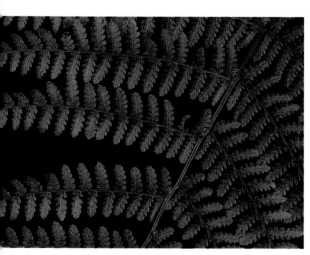

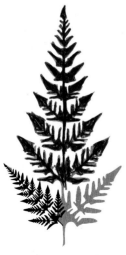

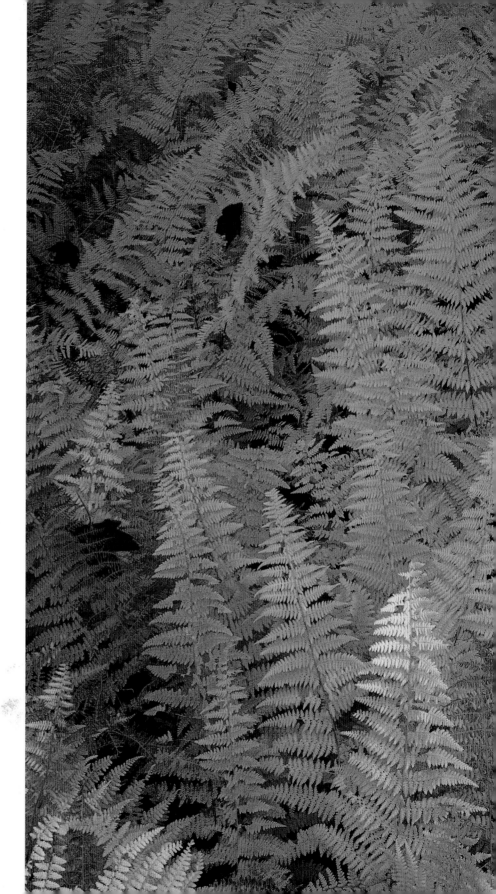

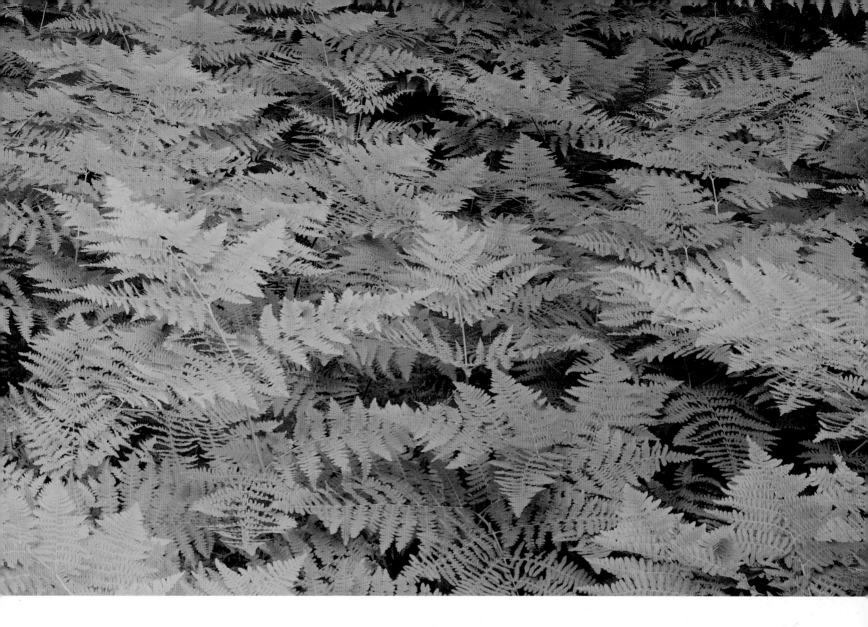

BRACKEN FERNS

NORTH PEAK
*Yosemite National Park, California*

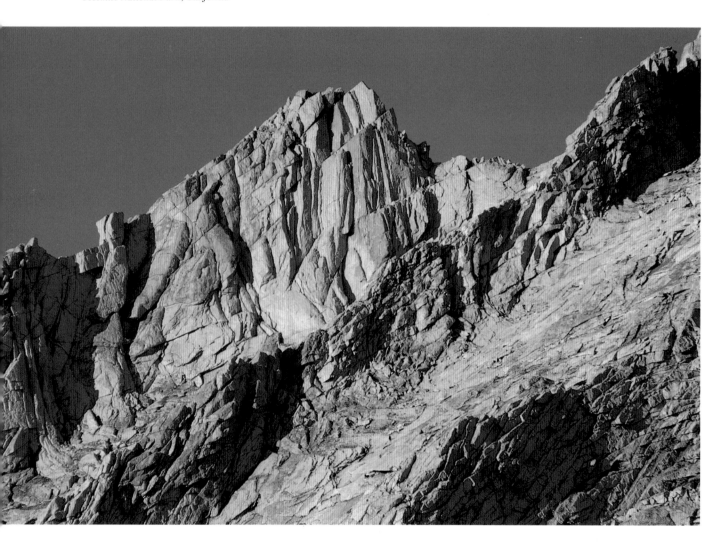

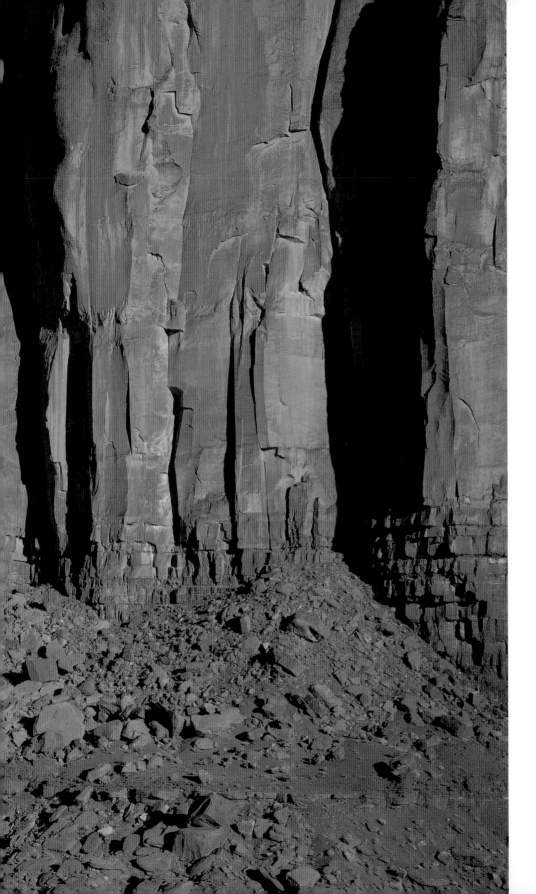

**The simple forms** of traditional Euclidean geometry don't match the shapes of the natural landscape. Benoit B. Mandelbrot, the creator of fractal geometry, wrote: "Clouds are not spheres, mountains are not cones, coastlines are not circles, and bark is not smooth, nor does lightning travel in straight lines." Fractal geometry has enabled geologists to analyze these irregular forms that occur in the natural landscape, describing the cragginess of a mountain peak or the roughness of cracking slate.

SLICKROCK CLIFFS
*Monument Valley Navajo Tribal Park, Arizona*

ROCK DESIGN
*Great Smokey Mountains National Park*
*North Carolina*

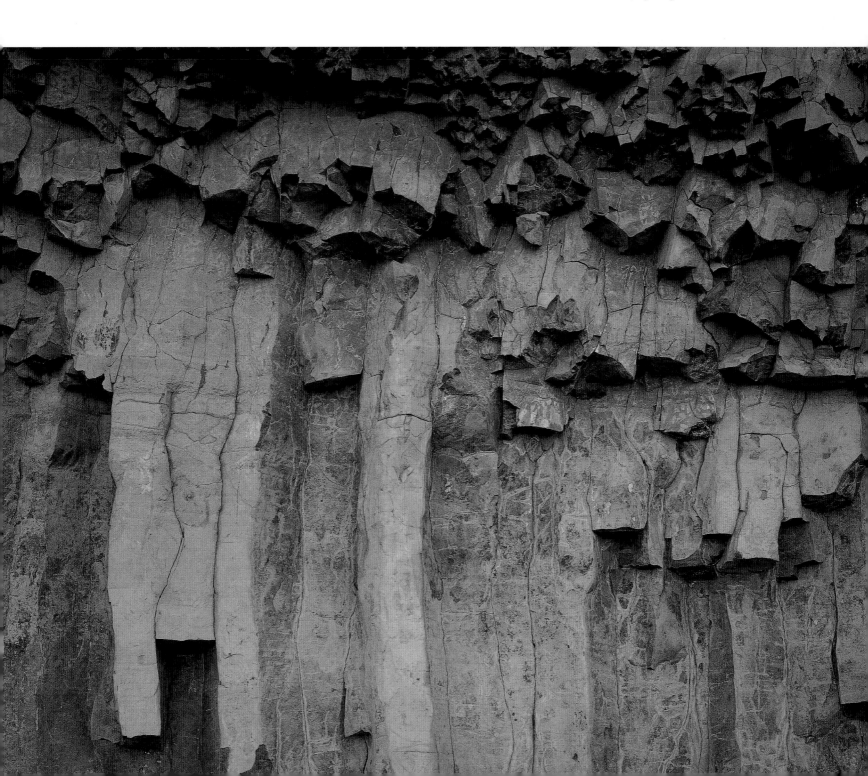

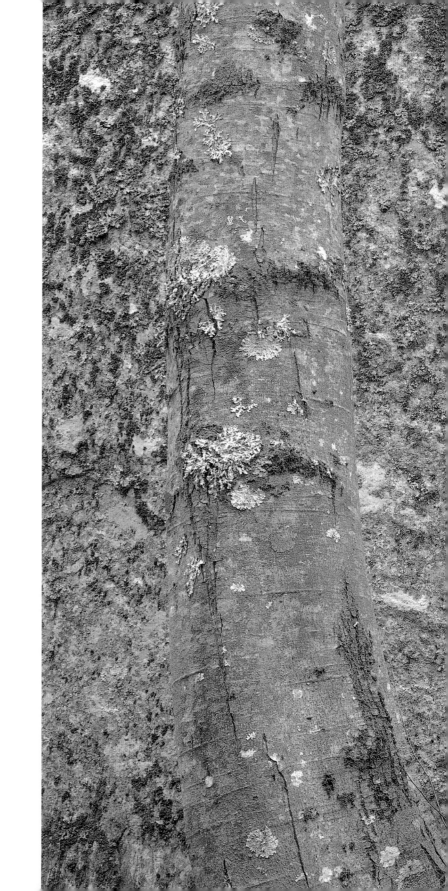

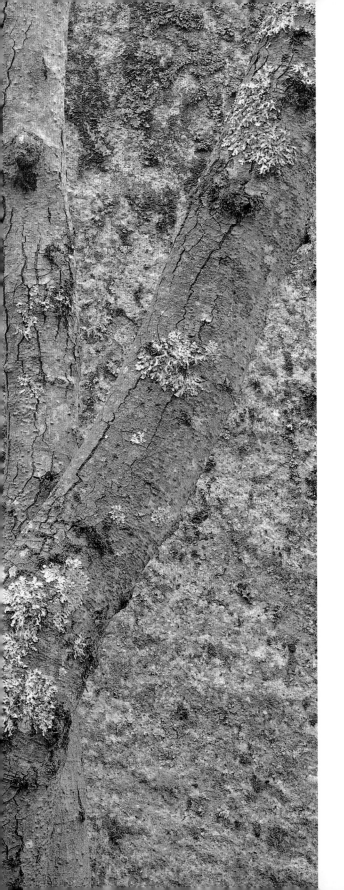

## LICHEN

Each patch of lichen has a jagged and irregular shape. Look more closely at the edge of a patch, and you'll see new irregularities. Like fractal forms, these lichen patches have wrinkles upon wrinkles upon wrinkles. To determine whether these irregular patches are fractals, you would need to compare their wrinkles at various magnifications. Fractal forms look very much the same at a variety of scales.

**The California coast,** with all its irregularities, offers a classic example of a fractal pattern. The precise length of the coastline depends on the size of your measuring device. If you traveled the length of the coast on your hands and knees with a yardstick, you could measure the ins and outs of middle-sized bays and irregularities. If you used a ruler, you could add to the length, by measuring smaller wiggles in the coastline. And if you tracked the path of an ant that followed each tiny irregularity in the coast, you'd get a still larger number. For fractals, length is not a unique measurement.

BIG SUR COAST
*Julia Pfeiffer Burns State Park, California*

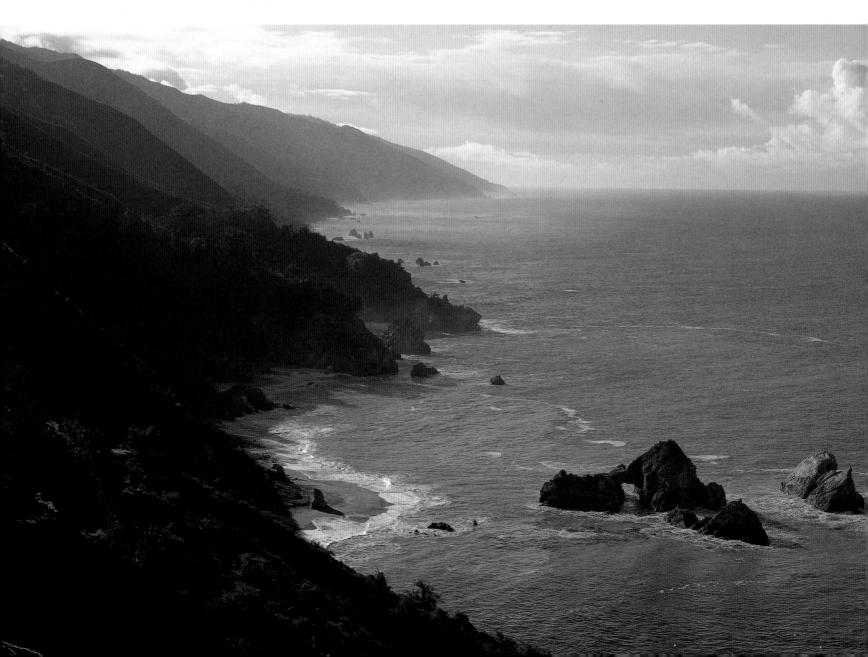

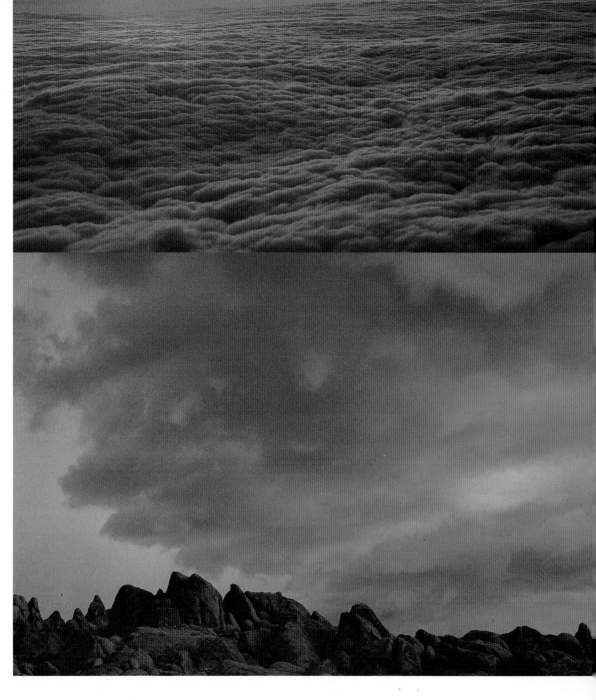

*Aerial view of* C L O U D S

Analysis of clouds reveals that they have the same level of irregularity over an enormous range of sizes. The shape of a cloud provides no clue to its size. The cloud could be as big as a car, a house, or an entire city block—the billows and whorls look about the same.

S U N R I S E   C L O U D S
*over the Alabama Hills, California*

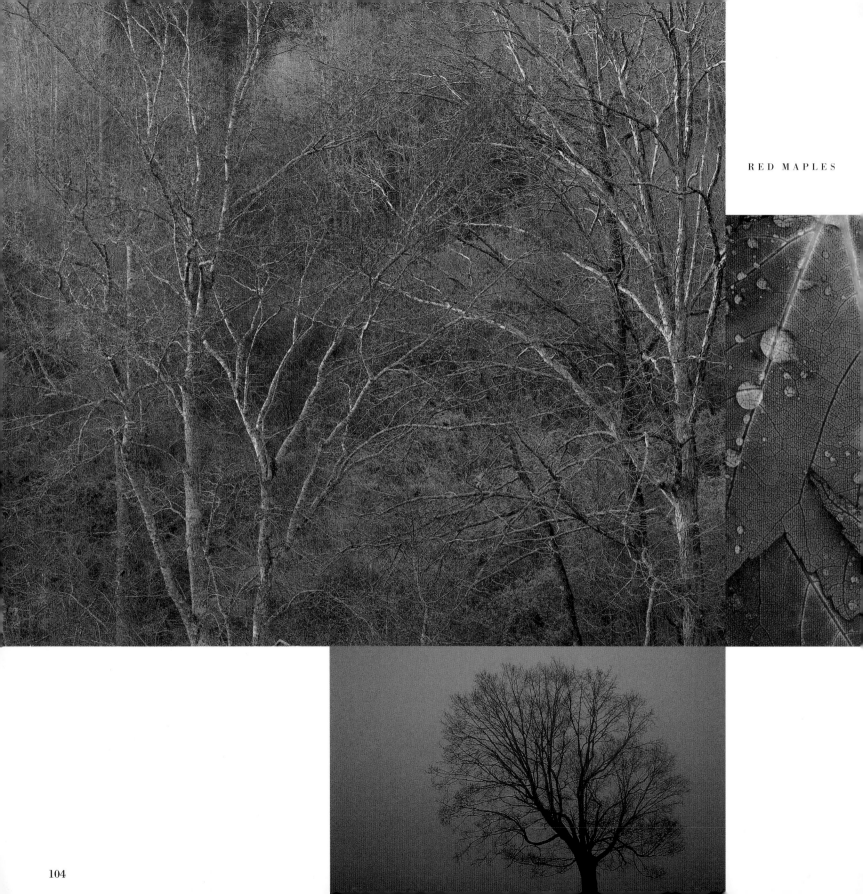

A tree may repeat the same pattern of branching in a variety of situations, in a fractal pattern of growth. The branches sprouting from a maple sapling, for example, are arranged in pairs, with each pair at right angles to the pair below it. That same pattern repeats in the sprouting leaves on the branches. In the mature tree, this repetitive pattern may be difficult to spot. Environmental factors influence whether a leaf grows or withers, whether a branch grows strong or is stunted, thus influencing the overall form of the tree. Each species of tree has its own pattern of branching.

BALSAM FIR

# Afterword   *William Neill*

*Photographer's Notes*

The art of photographing nature is largely a matter of perception and immersion. The experience of exploring and seeing clearly is the primary goal. If a photograph is to reveal more than a description of the subject, if it is to evoke a sense of wonder and mystery, then the photographer must feel and see deeply the essence of the subject. To design such an image, the photographer often makes use of line, shape, form, and texture to create a strong composition. It is also in these patterns that the rules of nature's design can be seen. For twenty years I have photographed the patterns of nature. Most often, even when photographing grand landscapes at my home base in Yosemite, I turn my eyes and my camera toward intimate details near at hand. I look for graphic design—the textured ripples of water in a stream or the cracked pattern in the bark of a tree. These things have long fascinated me without any real knowledge of the scientific principles involved. Most of the images in this book were made over the years with only the beauty of the subject as my motivation. Since I began working with the Exploratorium, I have had the pleasurable task of searching out subjects that illustrate specific patterns in nature. I explored wild beaches and forest floors, supermarket shelves and gift shops, my mother's kitchen and botanical gardens to find the perfect sea star, maple leaf, nautilus shell, honeycomb, kiwi fruit, amethyst crystal, wild grapevine tendril, or cactus thorns to photograph. My biggest challenge has been to create images that evoke both the artistry and the science of the subject. I hope that the images here will inspire curiosity and appreciation for the magic and mystery of

creation. As Rachel Carson writes in **The Sense of Wonder,** *Those who contemplate the beauty of the earth find reserves of strength that will endure as long as life lasts.* Only by seeing the natural world with a sense of wonder and beauty will we want to protect it.

*Technical Notes* The diversity of subjects necessary to illustrate this book required techniques particular to macro photography, landscape photography, and, in a few images, aerial photography. Working on this project allowed me to apply often-used techniques as well as develop new ways, at least for me, to photograph the patterns in nature. I have tried to apply the basic principles of good photography, which start with effective use of light and composition. I emphasize simplicity, both in my choice of equipment and in my images. Primarily, I use two camera formats. For most landscape photography, including the intimate details that I most often seek, I use a Wista 4x5 metal field camera. My lens choices include 90mm, 150mm, 210mm and 360mm focal lengths, with the 210mm and 150mm as my most frequent selections. The large viewing screen and slow speed of using a view camera lend themselves to a precise and contemplative approach to composing images. I have used Kodak Ektachrome, Polaroid ProChrome 100D, and Fujichrome Velvia Quickload over the years, and all three film types are represented in this book. Currently, I most often use the latter two films. I have happily used Nikon FE, FE2, and 8008 cameras, and Nikon lenses for my 35mm equipment for the past

twelve years. My lenses for 35mm include 24mm AF, 28-70mm AF zoom, 55mm and 60mm AF macro, 105mm, 80-200mm zoom, and 300mm focal lengths. My Nikon SB-24 Speedlight flash with a Quantum battery pack was used for all images with artificial light. Macro photography is often used to photograph the patterns in nature, as is evident in the pages of this book. In isolating the branching veins of a leaf or the ripples of a scallop shell, we can see both function and form more clearly. I used flash where I felt the pattern could be shown most clearly with artificial light. In several images I used my flash off camera with multiple exposure to precisely control the lighting. For example, the nautilus and the honeycomb images were made by setting off the flash from behind the subjects. Normally, prefer to use natural light, and with many of the found objects such as the Indian corn, the sunflower, and the sea urchin shell, I photographed them indoors using window light. Sound use of the technical aspects of photography is essential in producing high-quality images, but the most important ingredient is the photographer and his or her vision.

# Acknowledgments

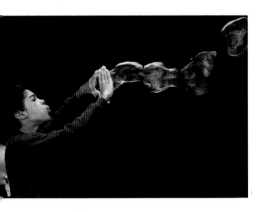

At the Exploratorium, no one works alone. This book would not exist without the efforts of many members of the Exploratorium staff and friends of the Exploratorium. Paul Doherty, the most enthusiastic physicist I know, served, as always, as my trusty scientific advisor. Rob Semper, Philip Morrison, and Phylis Morrison graciously reviewed the manuscript. Judith Dunham helped me shape the book when it was just a twinkle in our collective eyes and cheerfully edited the resulting manuscript. Ruth Brown and Ellen Klages ensured that I said what I meant and I meant what I said by making little red marks on the manuscript, even when I cried out for mercy. Mary Miller assisted with research about fractals and Nic Sammond tried to help me understand the poetry of meanders. Randy Comer and Esther Kutnick provided diagrams. Kurt Feichtmeir and Dominique Langlois kept me on schedule and provided endless support—both moral and administrative. And, of course, none of this would have been possible without the efforts of Caroline Herter and Fonda Duvanel of Chronicle Books. Thank you all for your assistance.

—*Pat Murphy*

The photographs in this book were made over the nearly twenty years I have been making images. I would like to thank all those who encouraged and supported me over the years. *By Nature's Design* started out in calendar form, so I would like to thank Charles Decker and Cynthia Hallock of Golden Turtle Press for their initial efforts and for introducing me to the fine people at the Exploratorium. At the Exploratorium, I could not have asked for better collaborators on this book. Kurt Feichtmeir kept us all on course through thick and thin. This book would have been impossible without Pat Murphy who, with few words, makes the concepts perfectly clear in her text. She served as my art director by giving me endless ideas and feedback on what objects would best illustrate patterns in nature for the book. Thanks to the people at Chronicle Books for pulling all our efforts together into a beautiful book. Thanks to Caroline Herter for seeing the possibilities in the beginning, to Fonda Duvanel and Judith Dunham for juggling the details of editing and production and to Lucille Tenazas for her inspiring design. Finally, thanks to my wife Sadhna for her ideas, enthusiasm and unfailing encouragement.

—*William Neill*

# List of Photographs

## Chapter 2

### MEANDERS AND RIPPLES

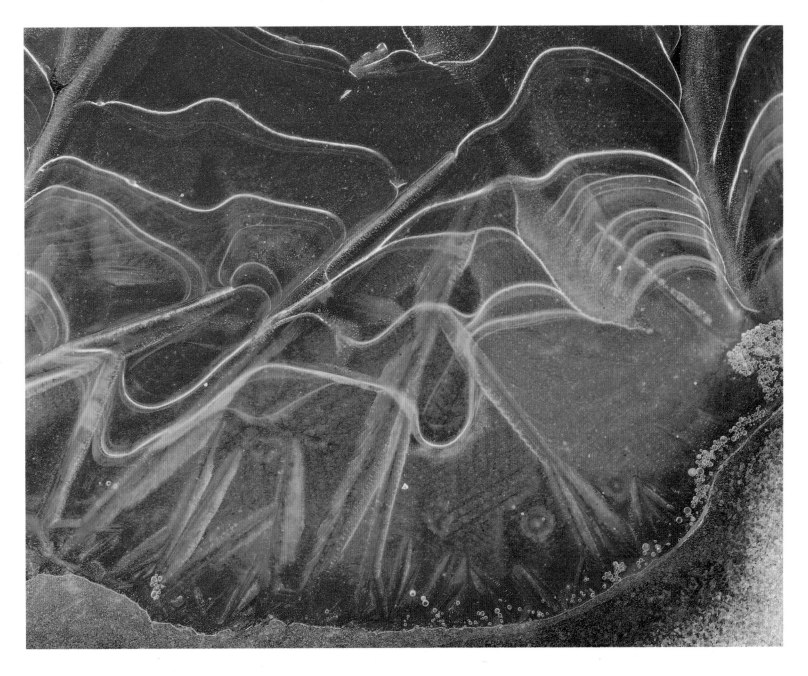

ICE PATTERN
*on the Tuolumne River,*
*Yosemite National Park, California*

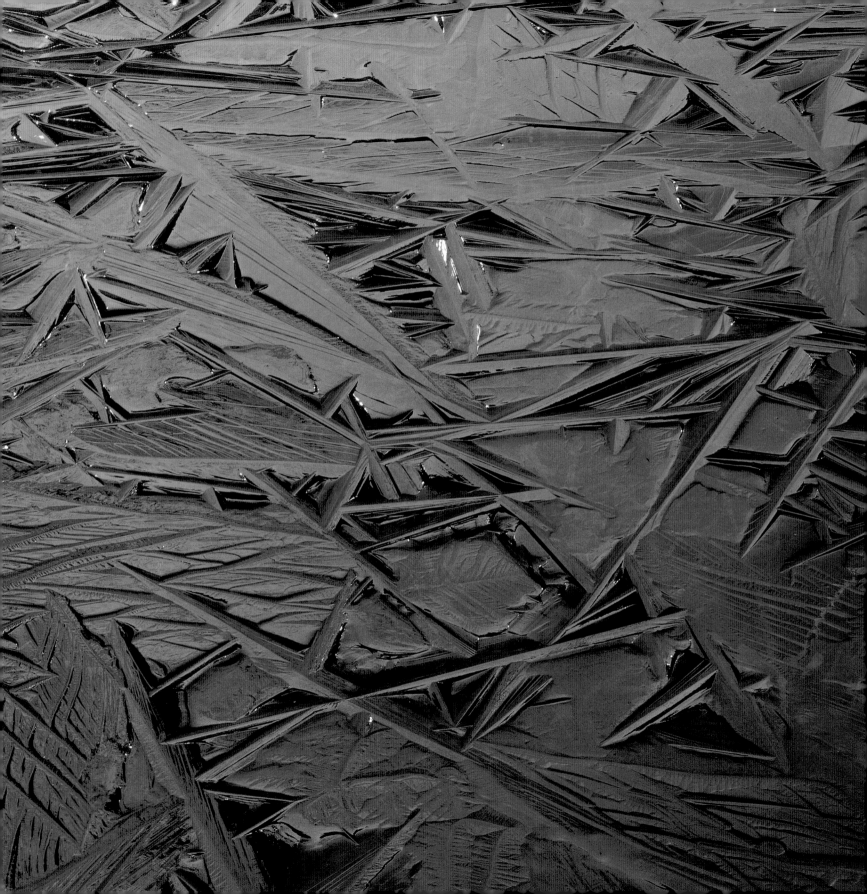

# Suggested Reading

If you would like to read more about the natural patterns described here, an excellent starting point is *Patterns in Nature* (Little, Brown, 1974) by Peter S. Stevens. Stevens offers particularly thorough explanations of packing, cracking, and branching, illustrated with black and white photographs and simple diagrams.

The chapter on "Pattern" in *The Search for Solutions* (Holt, Rinehart, and Winston, 1980) by Horace Freeland Judson contains a general discussion of natural forms and the human tendency to look for and recognize patterns in the world around us. *The Grand Design: Form and Colour in Animals* (J.M. Dent & Sons, 1982), a lavishly illustrated coffeetable book by Sally Foy and Oxford Scientific Films, examines how the patterns discussed in this book occur in the animal world.

You can find more information about why plants and animals grow in spirals in *On Growth and Form* (Cambridge University Press, 1961) by the British natural philosopher D'Arcy Wentworth Thompson and in *On Size and Life* (Scientific American Library, 1983) by Thomas A. McMahon and John Tyler Bonner. For a simple discussion of how natural spirals relate to the Fibonacci series of numbers, consult *Fascinating Fibonaccis: Mystery and Magic in Numbers* (Dale Seymour Publications, 1987), by Trudi Hammel Garland.

To learn more about the forms created by flowing water, consult *The Earth's Dynamic Systems* by W. Kenneth Hamblin (Burgess Publishing Company, Third Edition, 1985), an excellent geology text with an extensive discussion of stream branching and river meanders. *Geology Illustrated* (W.H. Freeman, 1966) by John S. Shelton provides numerous aerial photos of rivers, providing an opportunity to study branching and meandering from a different viewpoint. You can find further geological information and a discussion of sand ripples in *Sand* (Scientific American Library, 1988) by Raymond Siever.

The introduction to *The Fractal Geometry of Nature* (W.H. Freeman & Company, 1977) by Benoit B. Mandelbrot provides an overview of fractals, before plunging into mathematical analysis. *An Eye on Fractals* (Addison-Wesley, 1991) by physicist and photographer Michael McGuire provides a photographic examination of fractals, accompanied by a clear and comprehensive text.

# Index